ILLINOIS RAILROADS

Mike Danneman

First published 2022

Amberley Publishing
The Hill, Stroud
Gloucestershire, GL5 4EP

www.amberley-books.com

Copyright © Mike Danneman, 2022

The right of Mike Danneman to be identified as the Author of this work has been asserted in accordance with the Copyrights, Designs and Patents Act 1988.

ISBN 978 1 3981 0309 2 (print)
ISBN 978 1 3981 0310 8 (ebook)

All rights reserved. No part of this book may be reprinted or reproduced or utilised in any form or by any electronic, mechanical or other means, now known or hereafter invented, including photocopying and recording, or in any information storage or retrieval system, without the permission in writing from the Publishers.

British Library Cataloguing in Publication Data.
A catalogue record for this book is available from the British Library.

Typesetting by SJmagic DESIGN SERVICES, India.
Printed in the UK.

Introduction

The area later known as the Illinois Territory was explored by Native Americans thousands of years before the French reached the region. The word Illinois originates from the French word 'Illini', an Algonquin word meaning 'men' or 'warriors'. French explorers Jacques Marquette and Louis Jolliet explored the Mississippi and Illinois Rivers in 1673. The region that would become Illinois was part of the French empire until passed to the British in 1763. The area was ceded to the new United States in 1773 and entered the Union and became a state in 1818.

Illinois' lack of topography – less that 1,000 feet separate the highest and lowest elevations in the state – earned it the nickname 'the Prairie State'.

Situated in the midwestern United States, the state of Illinois is truly a crossroads for railroads. Anchored by Lake Michigan and Chicago in the north-east and the Mississippi River to the west, railroads in Illinois were built with the nation's westward expansion. By 1842 the first 59 miles were complete, linking the state capital of Springfield to the Illinois River with a railroad named the Northern Cross. This section of railroad still exists today as a vital part of Norfolk Southern's route between Detroit and Kansas City.

Chicago, being a western outpost for Great Lakes Shipping, built its first railroad in 1848. The Galena & Chicago Union connected Chicago to the Des Plaines River at Maywood with 10 miles of track, and other small lines quickly followed. Only a few years later though, railroads were being built into Illinois from the east, and by 1854 there were already ten railroads terminating in Chicago. Lines expanded to the west, north and south, soon hauling provisions and raw materials to a growing city, and dispatching more of the same, plus Illinois manufactured and grown goods to America's eastern seaboard. Expanding even further west, the first railroad bridge built over the Mississippi River opened for traffic in Rock Island on 21 April 1856.

While the northern portion of Illinois was crisscrossed with tracks to and from Chicago, southern Illinois also saw development as railroads tapped Mississippi River trade at a burgeoning St Louis. Difficulty bridging 'Old Man River' at St Louis was finally overcome in 1874, allowing the city to also become a gateway for railroads.

By the 1880s, Illinois had become the fourth populous state, and extensive European immigration provided farmers for the land and laborers for coal mines, steel mills and growing manufacturing centers. The state's population was over 5.6 million people in 1910, and by 1920, Illinois had become one of the leaders in nearly all aspects of

the economy, such as coal mining, heavy industry, farming, wholesaling, warehousing and transportation, which included over 12,000 route-miles of railroad! The growth wasn't just in the Chicago and St Louis sectors, as central Illinois cities like Peoria and Decatur became major manufacturing and agricultural centers.

In its heyday, hundreds of passenger trains would arrive and depart Chicago from six major downtown stations. Famous passenger trains like the *Twentieth Century Limited*, *Broadway Limited*, and *Super Chief*, along with fleets of Zephyrs, Rockets, Hiawathas and scores of others, connected Illinois with the rest of nation. Moreover, commuter trains far outnumbered these limited and named trains, and, along with freight trains from dozens of carriers, all added to the train count and congestion. Chicago even billed itself as the railroad capital not of America, but of the world. As poet Carl Sandberg (born in Galesburg, Illinois, in 1878) so eloquently put it, Chicago was indeed 'the nation's freight handler'.

Even after this golden age of railroading, the immense variety of railroads that still served the needs of Illinois was remarkable. Chicago is still the nation's busiest rail gateway, with St Louis being the third, after Kansas City, and much of St Louis' rail infrastructure is located in the state of Illinois. At the present time, Illinois has over 7,000 route-miles of track, ranking it second in rail milage behind the huge state of Texas. Illinois is a place where eastern and western railroads still converge, along with regional railroads, numerous short lines and terminal railroads. Amazingly, nearly one third of all railroad traffic in the United States passes through Chicago on 500 freight trains a day!

As wondrous as all the freight tonnage is in Illinois, today's passenger train network does not disappoint either. Metra, Chicago's regional commuter agency, has eleven routes fanning out from downtown that operate over 700 trains on weekdays. In addition, Amtrak has almost sixty trains a day arriving and departing Chicago Union Station, and Amtrak corridor trains on eight routes serve different parts of Illinois and nearby states.

Growing up in Wisconsin, a state bordering to the north, made Illinois an easy, target-rich land worth visiting for someone interested in railroads. One day could be spent on the Burlington Northern main line to Savanna, and the next on the Santa Fe or Illinois Central. And if one just wanted to see a lot of railroads, a tour of the Chicago area was in order.

For this book, I decided to feature my photography of Illinois' railroads from 1982 to 1997 – fifteen years during which there were an incredible amount of railroads still serving the state – before a major round of mega-mergers reduced color and diversity. We will begin the excursion with a quick tour of Chicago before sweeping across the northern part of the state to the Mississippi River. We'll then follow BN's C&I (Chicago & Iowa) route from East Dubuque back toward Chicago, reversing directions with Chicago & North Western's line towards Clinton, Iowa. Next, we'll look at BN's Aurora to Galesburg main line, along with Santa Fe's busy railway across the state. A trip south on the Illinois Central main line will take us to the fascinating railroads of central and southern Illinois. With so much to see, I hope you enjoy my glimpse of the railroads of Illinois.

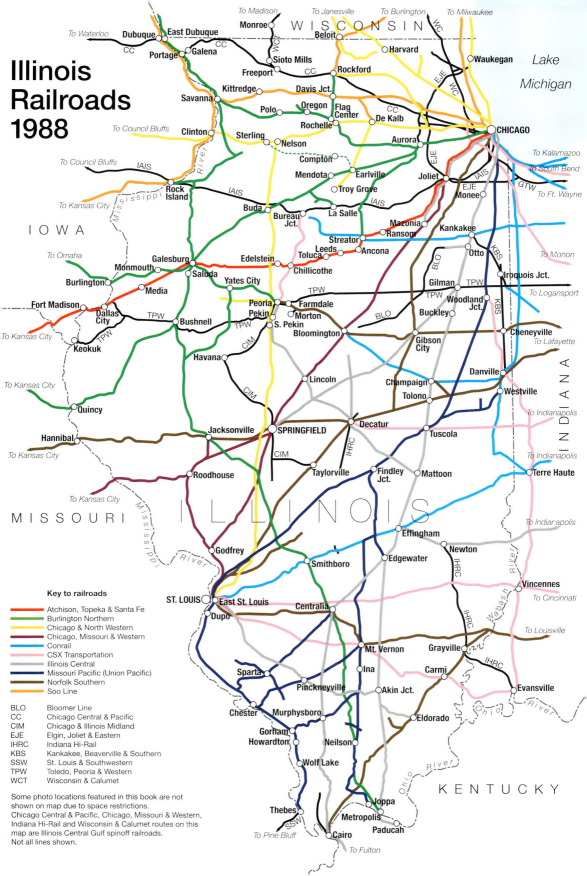

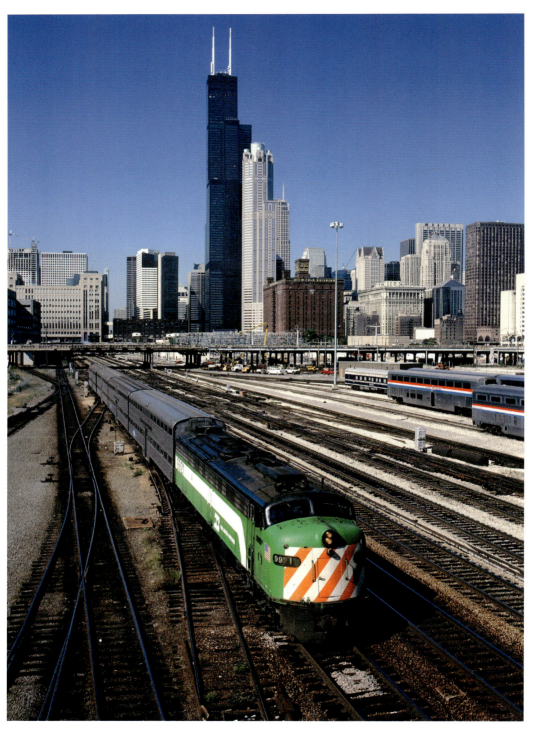

Burlington Northern EMD E9 No. 9921 leads a westbound Metra commuter train out of Chicago on 1 September 1991. Dominating the background is 108-story, 1,450-foot Sears Tower. At completion in 1974 it was the tallest building in the world, a title it held for nearly twenty-five years.

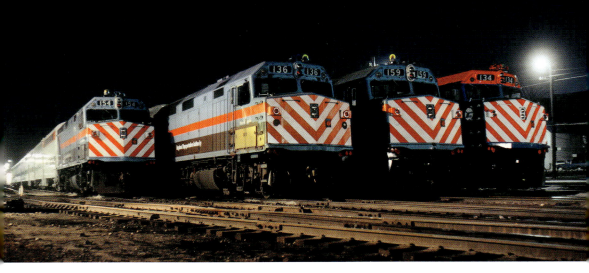

Ready for another trip to Chicago, RTA (Regional Transportation Authority) commuter trains wait out the night in the yard at Waukegan on 22 November 1986. RTA EMD F40PH Nos 154, 136 and 159 are painted in RTA colors, while F40PH No. 134 is freshly painted in new Metra colors, not long after the formation of Metra (short for Metropolitan Rail) in 1985.

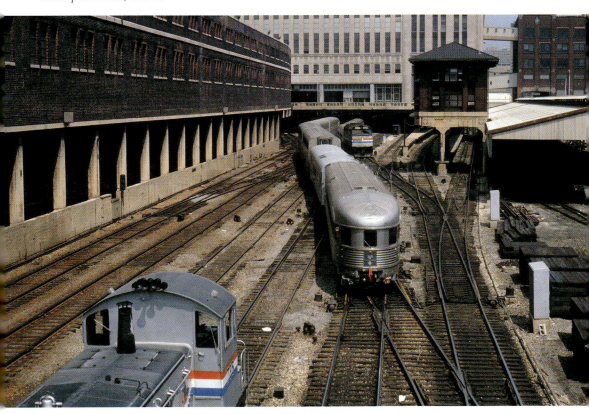

In May 1982, former New York Central tavern-lounge-observation car No. 48 trails an Amtrak train into Chicago Union Station, scissoring past Amtrak EMD SW1 No. 736 and EMD F40PH No. 249 leading another passenger train. This observation car was frequently seen on Amtrak trains in and out of Chicago during this era. Harrison Street Tower is no longer used today and is totally encased in a new post office building.

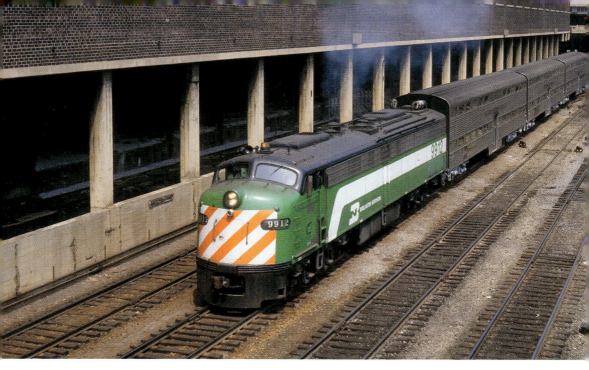

In May of 1982, a westbound Burlington Northern 'Dinky' departs Chicago Union Station in a view from Polk Street overpass. Chicago, Burlington & Quincy, and later BN, affectionately used the term 'Dinky' when referring to a commuter train.

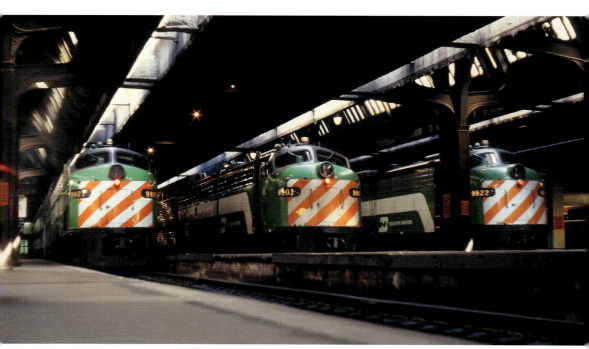

Metra trains powered by Burlington Northern EMD E9A locomotives assemble at Chicago Union Station in October 1983, waiting patiently for commuters to board for a trip home to the western suburbs. A total of twenty-five former CB&Q E8A and E9A units were remanufactured by Morrison-Knudsen in 1973/4 and 1978 into E9A locomotives for commuter service on BN's triple-track main line to Aurora.

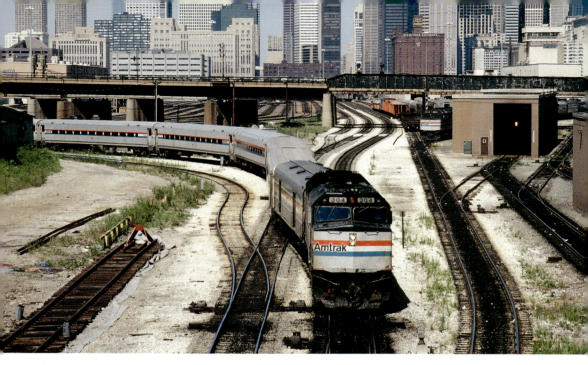

An Amtrak regional passenger train is in the process of being turned on the wye west of Amtrak's Chicago locomotive facilities on 1 September 1991. The tracks directly above EMD F40PH No. 304 lead to Chicago Union Station.

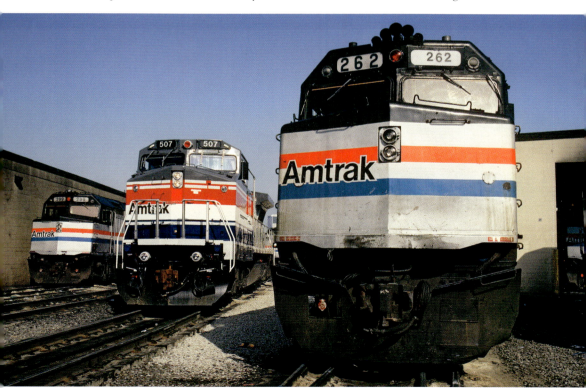

Amtrak Electro-Motive Division F40PH Nos 262 and 299 bracket new General Electric P32BWH No. 507 at the passenger carrier's locomotive facility in Chicago on 22 February 1992.

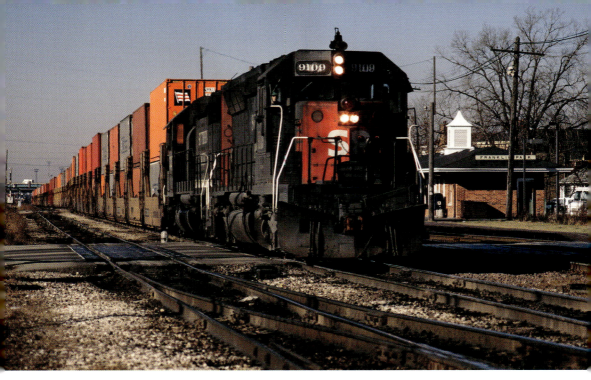

Southern Pacific EMD SD45 No. 9109 leads an eastbound double-stack container train through Franklin Park on 5 December 1987. Franklin Park is north-west of downtown Chicago on Soo Line's former Milwaukee Road trackage.

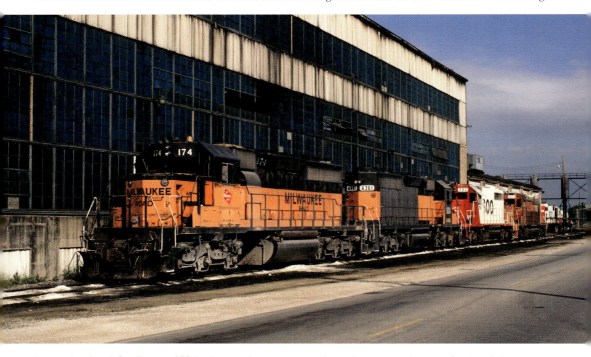

Milwaukee Road, Soo Line and Helm Leasing locomotives sit alongside the enginehouse at Soo Line's Bensenville Yard locomotive facility, along Green Street in Bensenville on 13 September 1987. Behind Milwaukee Road EMD SD40-2 No. 174 is Soo Line No. 6361. Patched and renumbered Milwaukee power on the Soo were nicknamed 'bandits', and were not particularly attractive or well done, as readily seen on No. 6361.

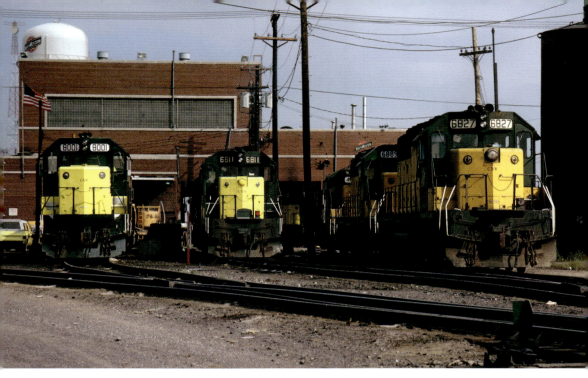

Chicago & North Western locomotives await assignment at the railroad's engine facility at Proviso on 13 September 1987. C&NW's Proviso Yard was the railroad's major yard in the Chicago area.

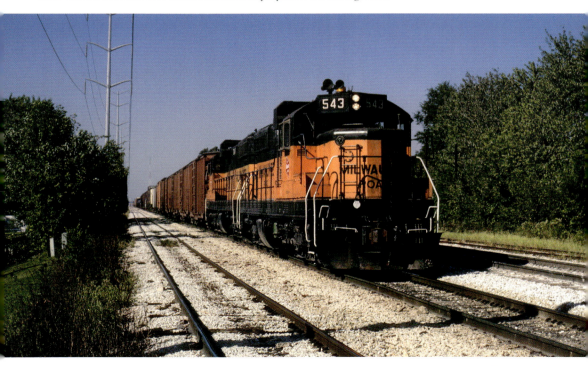

A pair of Milwaukee Road SD10s pull a long freight train through La Grange Park as it approaches the Harding Avenue grade crossing on 15 September 1985. These six-axle SD10 locomotives are rebuilt EMD SD7s, with the work done in Milwaukee Road's own shop in Milwaukee, Wisconsin.

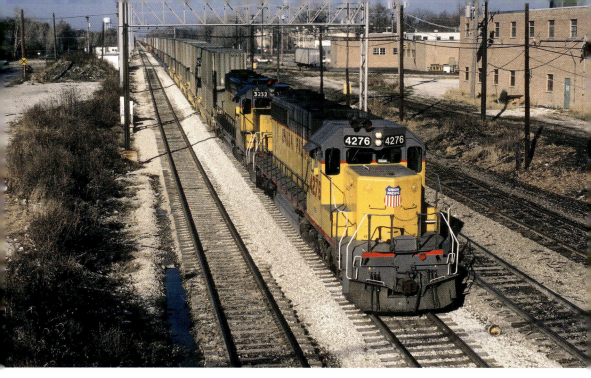

A pair of Union Pacific EMD SD40-2s power a long double-stack intermodal train southbound on the Indiana Harbor Belt at La Grange on 22 November 1986. UP No. 4276 is former Missouri Pacific No. 3276.

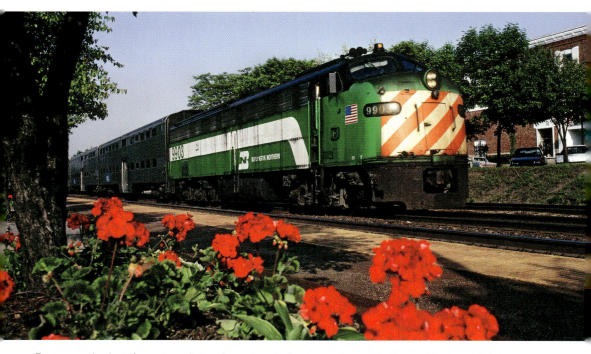

Passing neatly planted geraniums lining the station platform, a westbound Burlington Northern 'dinky' commuter train rips through Hinsdale on a pleasant 28 May 1992. By this date, commuter trains on BN's three-track main line were powered with a mixture of BN E9s and Metra's new F40PHM-2, a locomotive type that would retire all twenty-five E units.

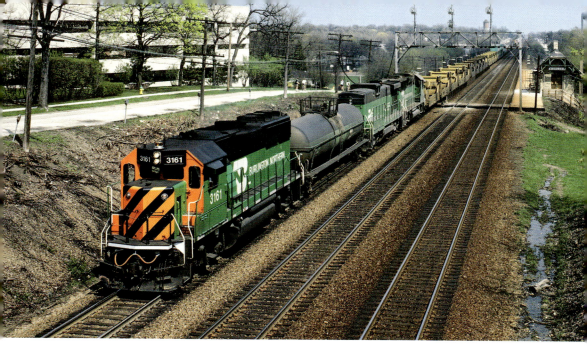

On 18 April 1987, a westbound Burlington Northern intermodal train flies through Highlands. Powering the train is EMD GP50 No. 3161, followed by a fuel tender, a GE B30-7A 'B unit' and another GP50. BN No. 3161 has an extended cab to house room for more crew members, since this was the era of trains going cabooseless. Five tiger-striped BN GP50s (Nos 3158–3162) were outfitted with this custom cab.

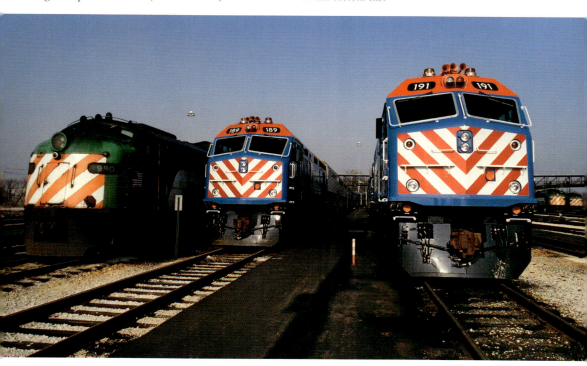

Commuter trains on BN's main line to Aurora lay over in the Metra's Hill Yard located there on 22 February 1992. By this date commuter trains on BN's route were powered with a mixture of BN E9s and Metra's new F40PHM-2s, a locomotive model that would retire all twenty-five E units.

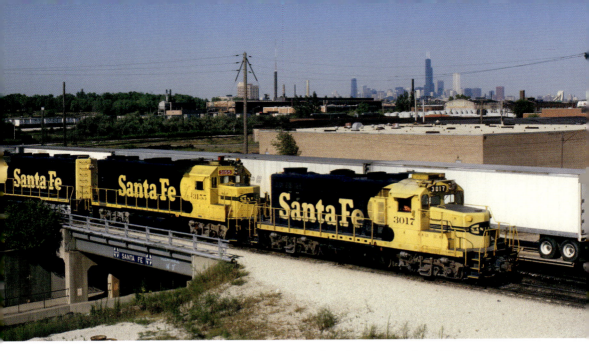

As a piggyback (semi trailers on flat cars) train departs the yard westbound, an eastbound Santa Fe freight led by EMD GP20 No. 3017 crosses West 38th Street overpass into Corwith Yard at Chicago on 30 August 1986. In this view from the roof of the yard tower, the Hancock Building and Sears Tower can be seen in downtown Chicago in the background.

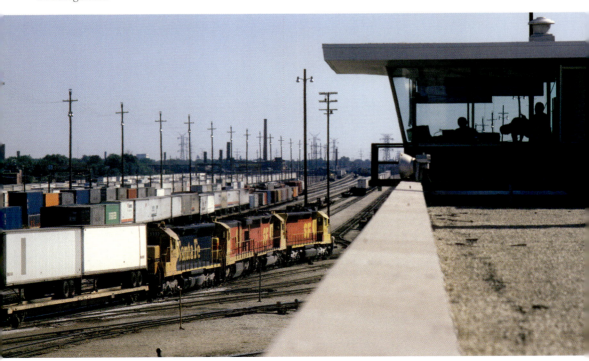

In a view from the yard office at Corwith, a Santa Fe intermodal train arrives at the yard, powered by a trio of red, yellow and black locomotives, painted for the ill-fated merger with Southern Pacific, and a more traditional Santa Fe-painted EMD SD45.

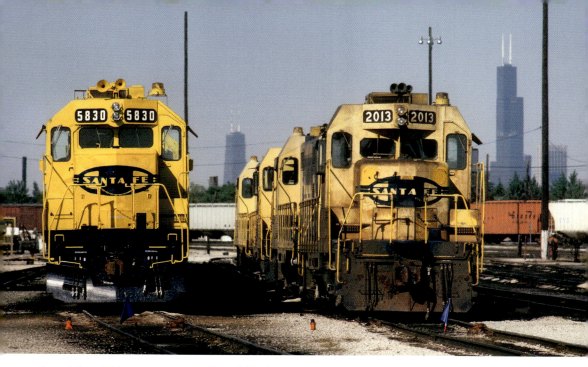

Several Santa Fe locomotives rest at Corwith Yard south-west of downtown Chicago on 30 August 1986. Left to right: the freshly repainted EMD SD45-2 No. 5830, the 100-story John Hancock Center, four EMD Geeps led by GP7u No. 2013, and finally the 108-story Sears Tower.

A northbound Indiana Harbor Belt freight, pulled by EMD SW1500 Nos 9201 and 9217, works though McCook on 13 September 1986. This busy location on the IHB main line is where it crosses the Santa Fe main line at grade.

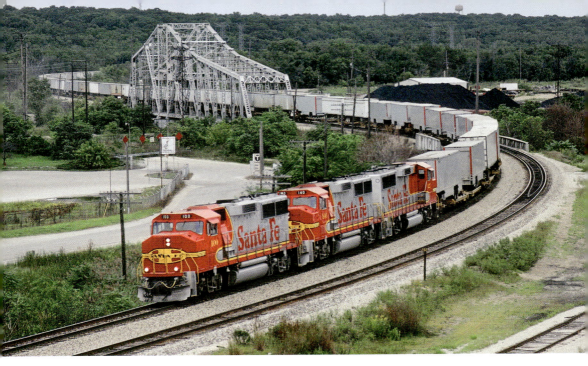

Santa Fe's 199, an intermodal train running from Chicago to Richmond, California, cruises into Lemont as it crosses the bridge over the Chicago Sanitary & Ship Canal on 2 September 1990. Three new EMD GP60Ms power the hottest train on the Santa Fe.

Some pigeons scatter as a southbound Grand Trunk Western freight rattles over one of the bridges spanning the Calumet Sag Channel into Blue Island on 3 December 1988. The truss bridge on the left is no longer being used and is cut off from the rest of the rail system.

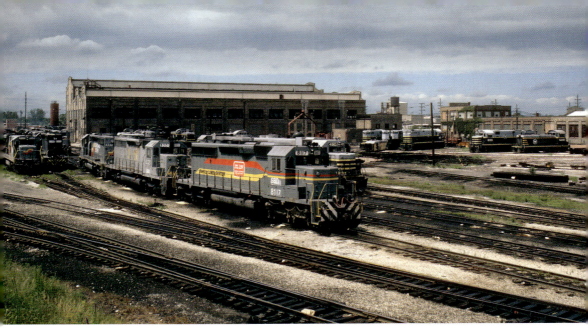

On 10 August 1986, the locomotive facility and shop area of Belt Railway of Chicago's Clearing Yard in Bedford Park hosts a large number of locomotives, mostly home-road and Seaboard System. Former Family Lines, Louisville & Nashville, Clinchfield and Seaboard Coast Line units can be seen, as well as those in Seaboard System gray. BRC Alco C424 Nos 600 and 601 are on the right resting on radial tracks off the turntable, while the main shop building dominates the background.

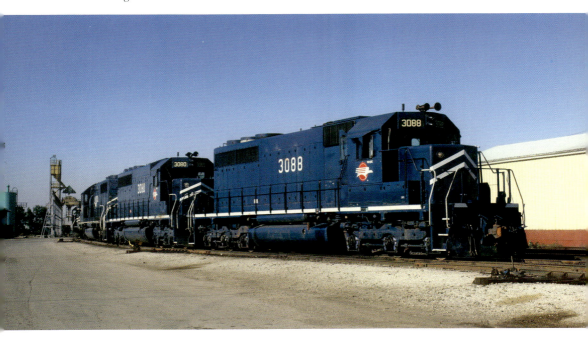

Even though Union Pacific and Missouri Pacific merged in 1982, the locomotive facility at Yard Center at Dolton still looks like pre-merger days as MP SD40 Nos 3088 and 3080, along with SD40-2 No. 3134, rest between runs on 15 September 1985. It wasn't until 1994 that all of the 'Jenk's Blue' locomotives were repainted, and because of outstanding bonds it took until 1 January 1997 for the Missouri Pacific to be officially merged into the Union Pacific Railroad by the Union Pacific Corporation.

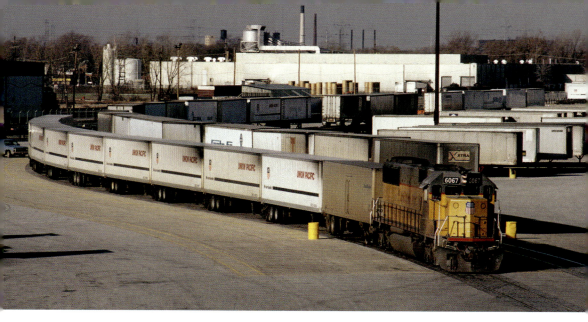

Powered by EMD SD60 No. 6067, Union Pacific's short-lived RoadRailer departs the former Missouri Pacific Dolton intermodal yard on its trip from Chicago to Dallas, Texas, on 3 December 1988. A RoadRailer van is a unique bi-modal trailer that can operate both over the highway as a semi-trailer and over the rail in trains. For rail operation, the trailer is mounted on the special RoadRailer Mark V rail bogie. Early RoadRailers were built with integrated railroad wheelsets that could be lowered into position when the trailer was pulled behind a train, but this ended up being an extra weight penalty on the highways, and were phased out.

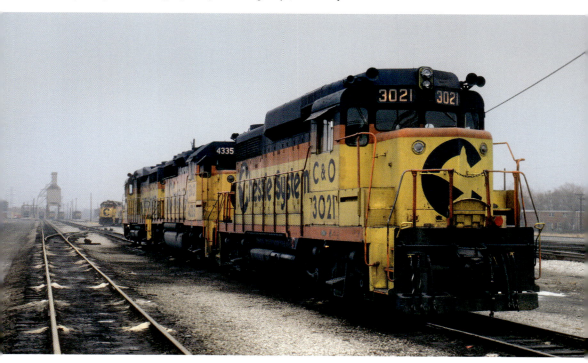

Chesapeake & Ohio EMD GP30 No. 3021, along with Baltimore & Ohio GP40-2 No. 4335 and sister C&O GP30 No. 3001, sit at Barr Yard at Riverdale on a cold and foggy 23 November 1986. Standing in the background is a coaling tower, a relic from the days of steam locomotives.

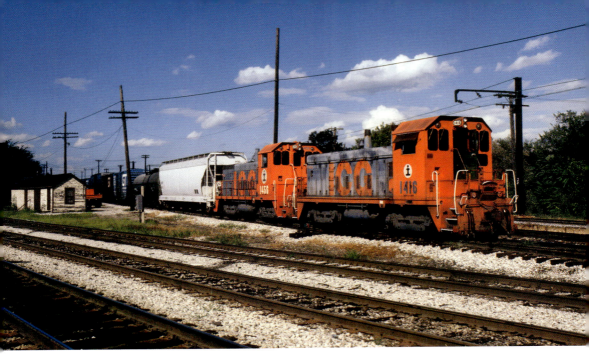

On 10 August 1986, Illinois Central Gulf EMD SW14 Nos 1416 and 1456 switch cars at the south end of Markham Yard at Homewood. These SW14 switcher locomotives are rebuilt EMD locomotives, remanufactured in the railroad's shops at Paducah, Kentucky.

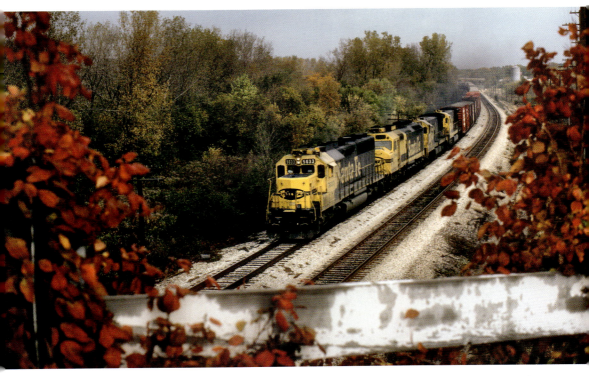

Led by EMD SD45-2 No. 5633, a westbound Santa Fe freight is about to duck under the old Division Street overpass at Lockport on a pleasant autumn day of 12 October 1985.

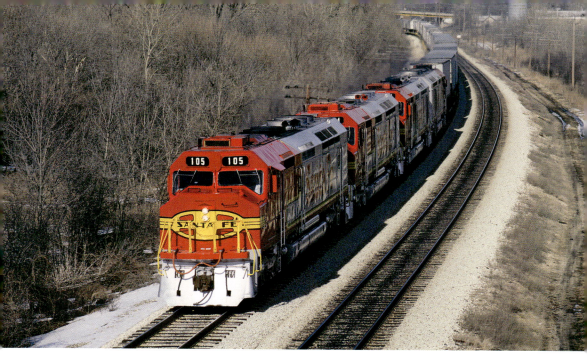

Santa Fe's 165 train speeds through Lockport led by a quartet of shiny 'Super Fleet' FP45 cowls on 25 February 1990. These 1967-built machines from EMD were recently repainted in red, yellow and silver warbonnet colors reintroduced by the Santa Fe in 1989.

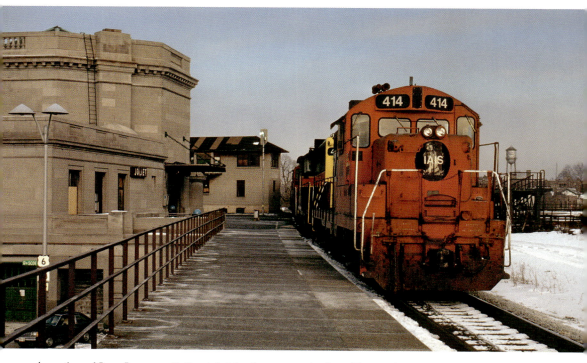

A westbound Iowa Interstate Railroad freight clatters over the Santa Fe main line at Joliet Union Station on the afternoon of 22 February 1989. Iowa Interstate was formed on 2 November 1984, to operate the former Rock Island main line between Chicago and Council Bluffs, Iowa.

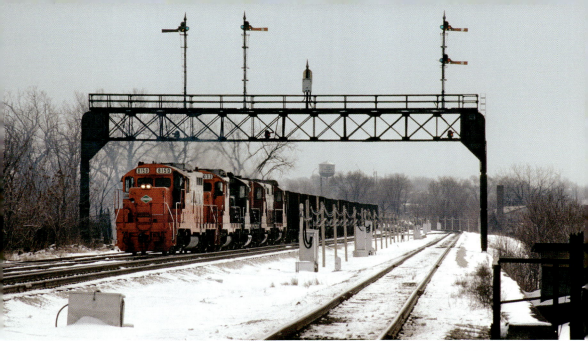

An eastbound Chicago Central & Pacific coal train rumbles through Joliet on 22 February 1989. CC&P was formed on 27 August 1986, to operate Illinois Central's Chicago to Omaha, Nebraska, main line and associated branches to Cedar Rapids and Sioux City, Iowa. Several regional railroads like CC&P and IAIS relied heavily on rebuilt GP8 and GP10 locomotives from Illinois Central Gulf as early power for their trains.

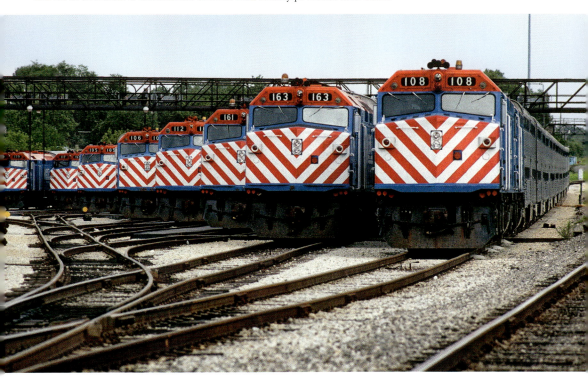

Metra commuter trains take the weekend off as they await hauling passengers back into Chicago on Monday morning at Joliet on 2 September 1990. All of these trains are led by EMD's popular F40PH passenger locomotive.

On Chicago & North Western's line operating from Chicago to Janesville, Wisconsin, two Metra commuter trains rest in the small yard at Harvard on 13 June 1993.

On 26 April 1987, a pair of Metra commuter trains, with locomotives still in RTA colors, sit alongside some Chicago & North Western power at Harvard. The brick factory in the background was the Hunt, Helm, Ferris & Co. that manufactured products to streamline farm work. When farmers started referring to the company's merchandise as the 'star' line of farmstead equipment, they renamed the corporation Starline in 1931.

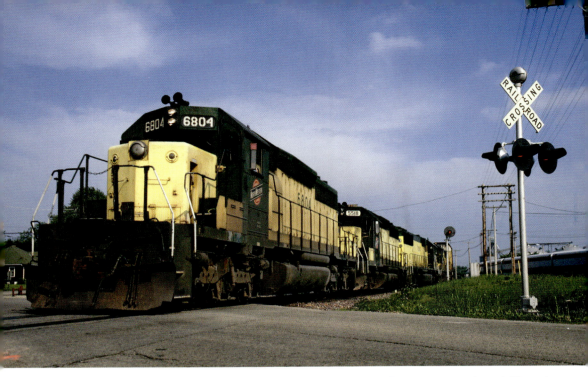

A westbound Chicago & North Western Railway freight crosses over Diggins Street as it passes through Harvard on its way Janesville, Wisconsin, on 13 June 1993.

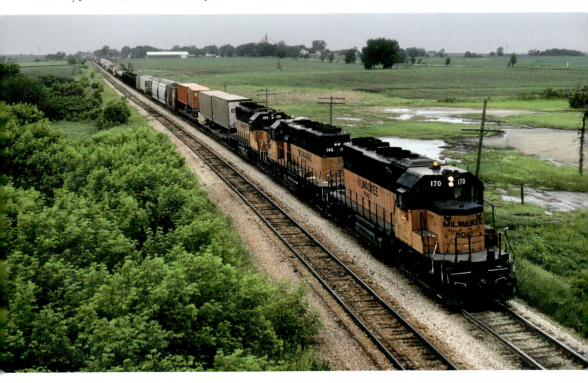

A 10 June 1984 view from the Illinois Highway 251 overpass sees an eastbound Milwaukee Road freight departing Davis Junction powered by three EMD SD40-2s.

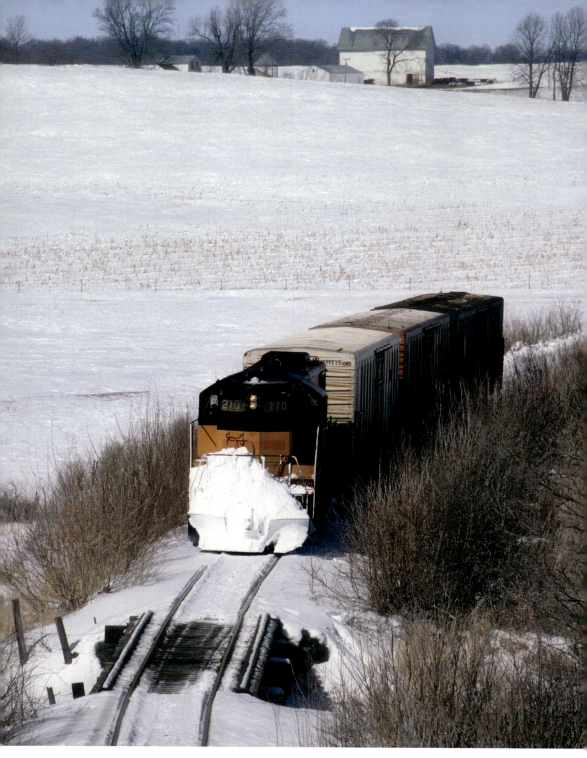

On a cold 17 February 1985 day, a short Wisconsin & Calumet freight slowly curves south at Oneco, just south of the Wisconsin state line. The train is traveling a little used former Illinois Central Gulf branch from Madison, Wisconsin to Freeport. Believe it or not, the three cars contain Huber beer and Swiss Colony cheese from Monroe, Wisconsin, a state well-known for both products!

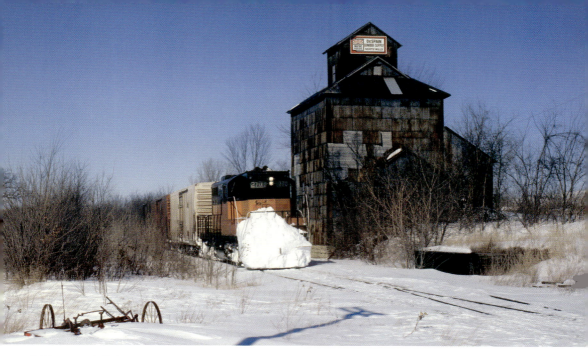

A Wisconsin & Calumet three-car freight trundles down a snow-covered former ICG branch line running between Madison, Wisconsin, and Freeport on 17 February 1985. A former Milwaukee Road GP9 serves as snowplow and power for the southbound train passing the De Spain lumber/supply elevator at Scioto Mills. The rarely used line was eventually torn up in late 1999 and turned into a bike path.

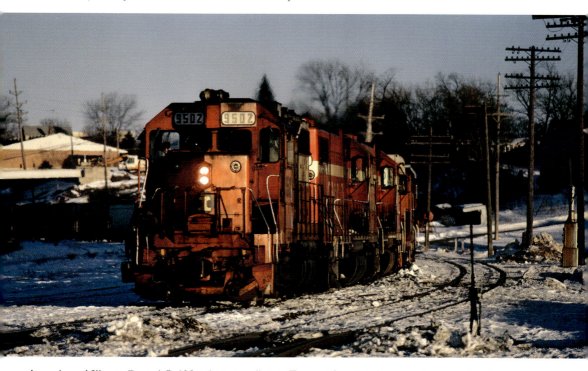

A westbound Illinois Central Gulf freight train rolls into Freeport for a late day crew change on 17 February 1985. The crew member with his grip (suitcase) in the shadows on the front steps is obviously ready to get off the train and call it a day.

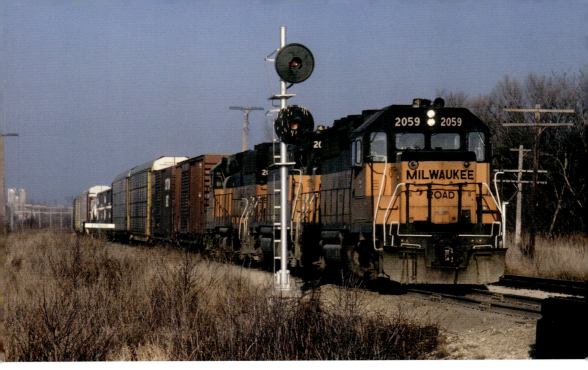

Rolling though Kittredge in November 1984, this westbound Milwaukee Road freight train is powered by a trio of EMD GP40 locomotives. Kittredge, on the Chicago to Savanna main line, is the junction of a Milwaukee Road line that ran north-east to Beloit and Racine, Wisconsin.

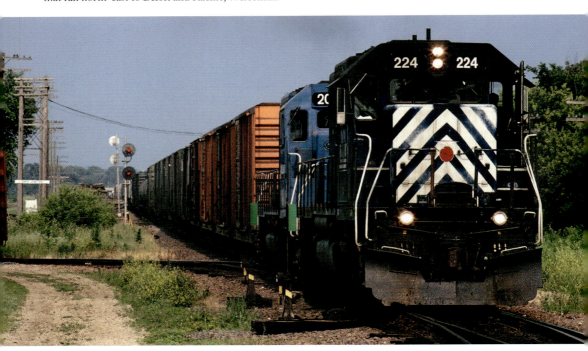

A westbound I&M Rail Link freight runs through Davis Junction on 29 June 1997. After Milwaukee Road was bought by Soo Line, Soo's parent Canadian Pacific Railway made some route changes in its system and sold off several lines to I&M Rail Link, including the Chicago to Savanna (through to Kansas City) route in 1997. The railroad was bought by Washington Corporations, who also owns Montana Rail Link.

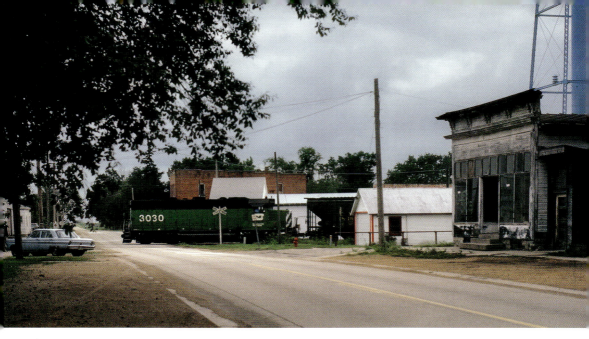

A Burlington Northern local slowly moves through the small town of Harmon on 10 June 1984. BN operated this former Chicago, Burlington & Quincy branch from Sterling to Earlville, known as the 10th Subdivision Branch Line of the Chicago Division. By this date, trackage of the branch was deteriorating and traffic dwindling.

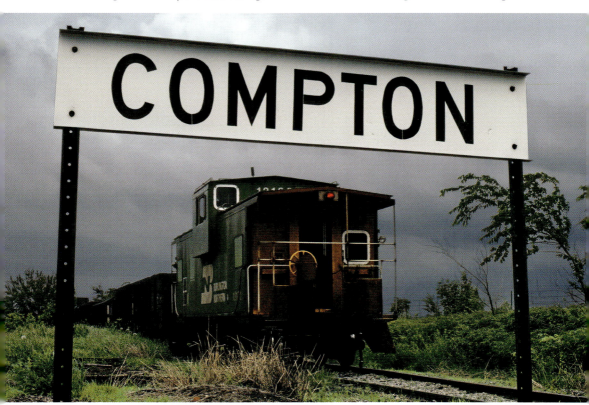

Caboose No. 12132 trails a Burlington Northern local through Compton on 10 June 1984. The 46.8-mile-long branch line between Sterling and Earlville would be torn up in 1985.

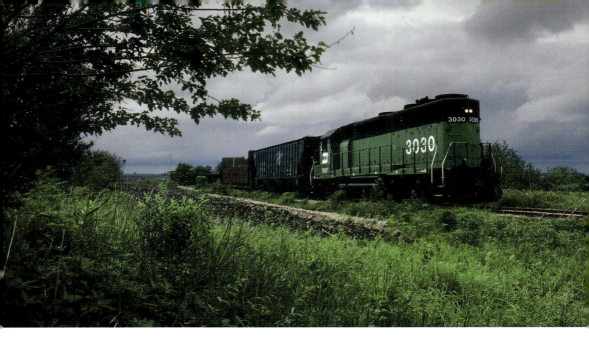

A Burlington Northern local freight rolls through Illinois farm country between Compton and Paw Paw on 10 June 1984. BN operated this former Chicago, Burlington & Quincy branch from Sterling to Earlville, and BN EMD GP40 No. 3030 is right at home, being the former CB&Q No. 630.

Burlington Northern's local operating from Sterling to Earlville pauses just north of Earlville. The branch used to cross Chicago & North Western's Troy Grove line here, but it now connects to C&NW 0.8 of a mile north of town, where BN has trackage rights to a connecting track at Earlville that curves eastbound onto the Chicago Division Second Sub main line running from Aurora to Galesburg. In this view at C&NW Junction on 10 June 1984, the BN local waits as a southbound C&NW train rumbles by. The BN local will enter C&NW trackage as soon as the trains bound for Troy Grove goes by.

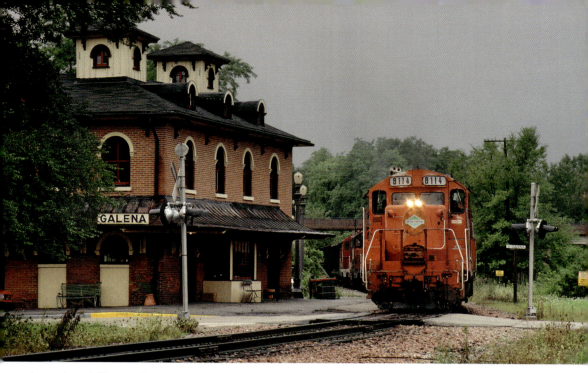

An eastbound Chicago Central & Pacific freight curves by the historic Galena depot on a rainy 13 August 1994. Galena is named after the natural mineral form of lead sulfide, and was mined here, and by 1845 Galena was producing nearly 27,000 tons of lead ore annually.

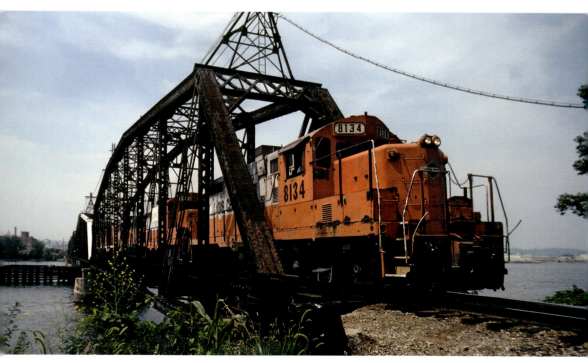

An eastbound Chicago Central & Pacific train, led by former Illinois Central Gulf GP10 No. 8134, crosses the mighty Mississippi River at East Dubuque on 20 July 1991. CC&P was formed in late 1985 from several spun-off Illinois Central Gulf lines.

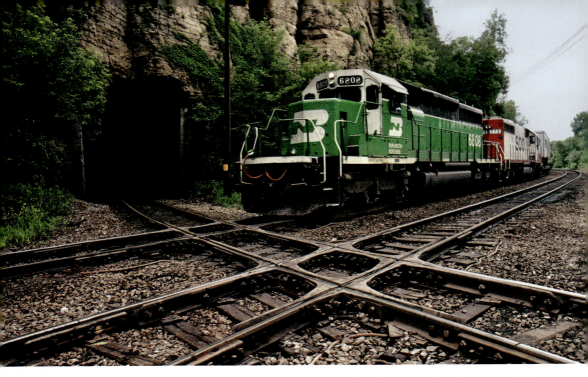

A Burlington Northern 'Expeditor' piggyback train is about to pound the diamonds at East Dubuque on 13 August 1994. A pair of colorful EMD SD40-2s pull the train – BN No. 6808 in pinstripe whiteface colors and Soo Line No. 770. At the west end of shared BN and Chicago Central & Pacific trackage is a scene very reminiscent of model railroads. CC&P's main line arcs away from the BN near the East Dubuque depot, enters a curved tunnel through a bluff, pops out of the bore and immediately crosses BN's double-track main and onto a bridge over the Mississippi River.

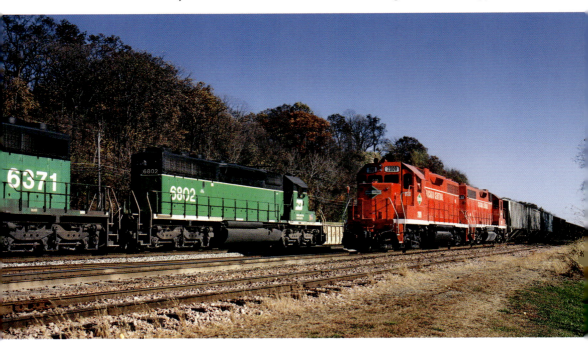

Chicago Central & Pacific train 51 meets an eastbound Burlington Northern freight at East Dubuque on 23 October 1993. Powering the westbound CC&P train are bright red EMD GP38 Nos 2009 and 2007.

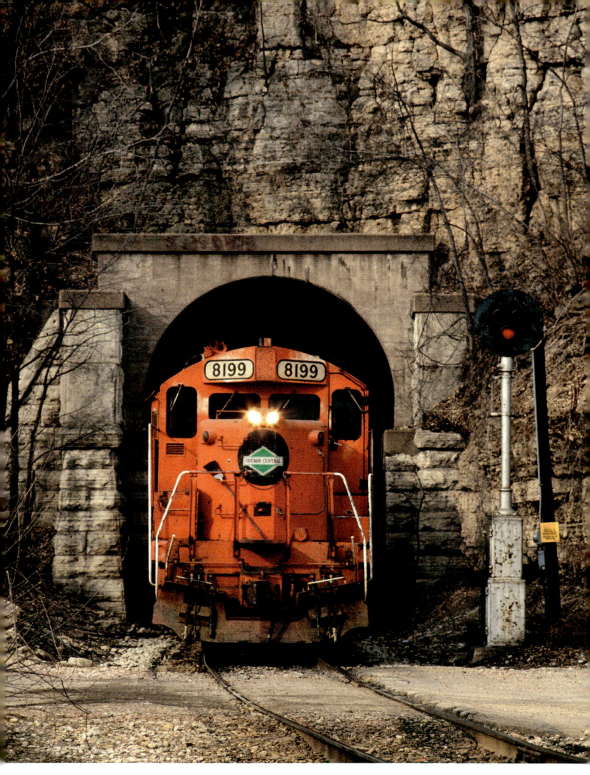
Chicago Central & Pacific EMD GP10 No. 8199 leads an eastbound train out of the curved tunnel at East Dubuque on 10 March 1991. Tunnels are rare in Illinois – this one, and three on the Illinois Central's Edgewood Cutoff in southern Illinois, are the only ones still used today.

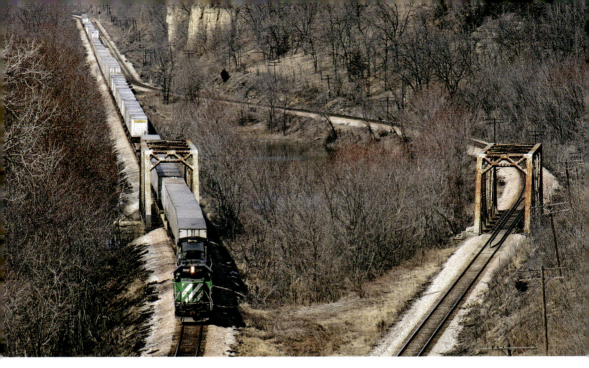

Burlington Northern intermodal train 2 crosses one of the truss bridges over the Sinsinawa River west of Portage on 3 April 1993. This location is on the BN/CC&P shared main lines along the Mississippi River between Portage and East Dubuque.

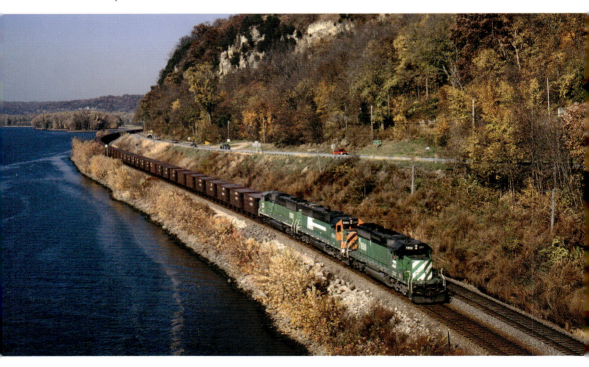

On the autumn day of 25 October 1992, a Burlington Northern taconite ore train headed for Granite City, near East St Louis, follows the bank of the Mississippi River at Savanna. The middle locomotive is one of three prototype EMD SD60 locomotives, originally painted in BN colors, but became part of EMD's lease fleet by this date.

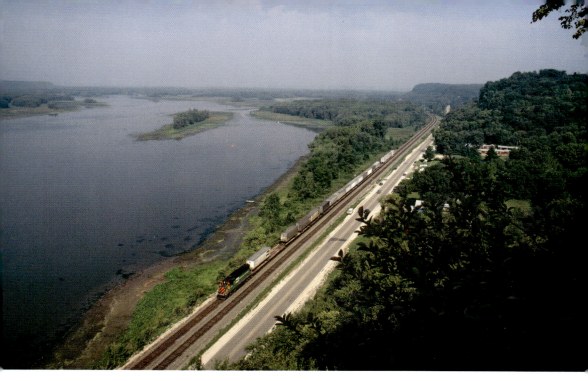

A short eastbound Burlington Northern 'Expeditor' intermodal train, pulled by lone EMD GP50 No. 3151, approaches Savanna in a view from Mississippi Palisades State Park on 5 September 1987.

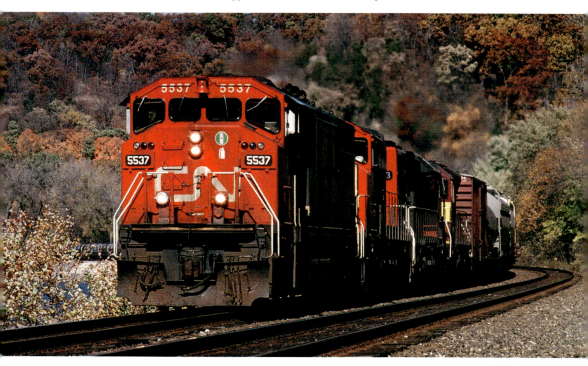

For several years, Canadian National's route to Chicago from the north-west was via trackage rights over Burlington Northern. On 19 October 1996, CN EMD SD60F No. 5537 leads an eastbound train past subtle autumn colors rimming the palisade bluffs west of Savanna.

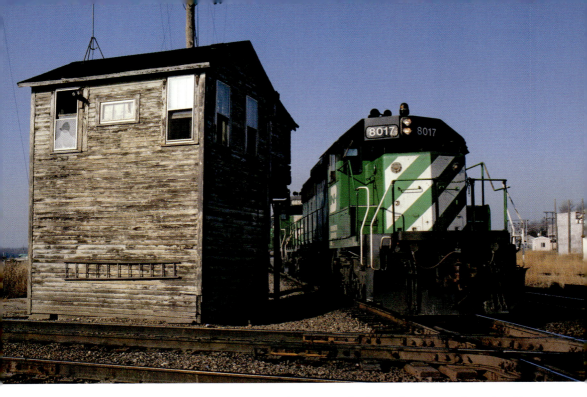

An eastbound Burlington Northern freight is about to thump across the diamond as it passes the creaky, old tower guarding the Milwaukee Road crossing of the BN at Savanna in November 1984.

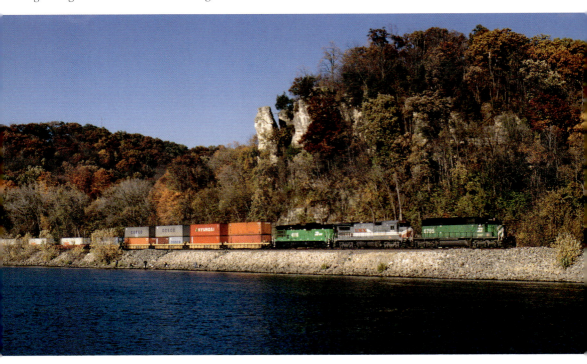

Burlington Northern EMD SD40-2 No. 6795 leads train 12 eastbound along the bank of the Mississippi River as it approaches Savanna at 4:10 p.m. on 19 October 1996.

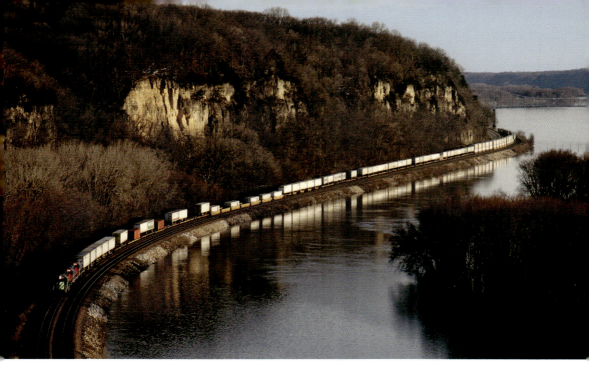

Burlington Northern train 3 softly reflects in the Mississippi River as it heads west of Savanna late in the afternoon of 3 April 1993. Trailing the BN EMD SD40-2 leading the train are two orange and blue Grand Trunk Western locomotives.

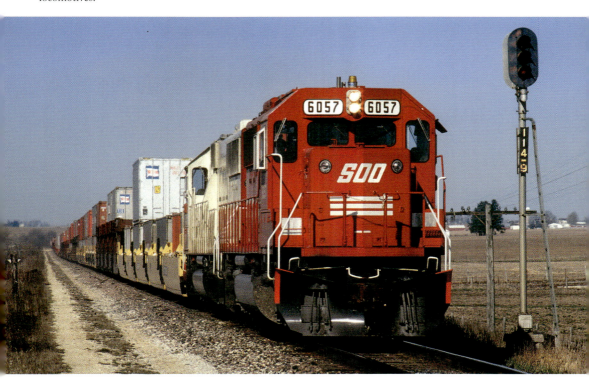

Soo Line EMD SD60 No. 6057 leads an eastbound stack train east of Lenark on 7 April 1990. This location is at mile 114.9 on the former Milwaukee Road main line between Chicago and Savanna.

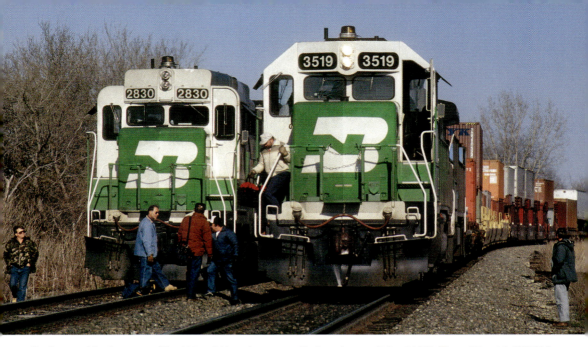

Burlington Northern train Nos 103 and 13 trade crews at Burke siding on 7 April 1990. Train 103, with GP39M No. 2830, was delayed leaving Chicago, creating some concern that the crew would not make it to the next crew change at La Crosse, Wisconsin. Instead of sending out a new crew, the dispatcher decided to exchange 103's crew with one that has worked less hours on a following train 13. The dispatcher got a fast intermodal train (two actually, as train 3 was right in front of 13) around a slow freight in single-track territory and allowed all the crews to make it to the next terminal, all in one well orchestrated move.

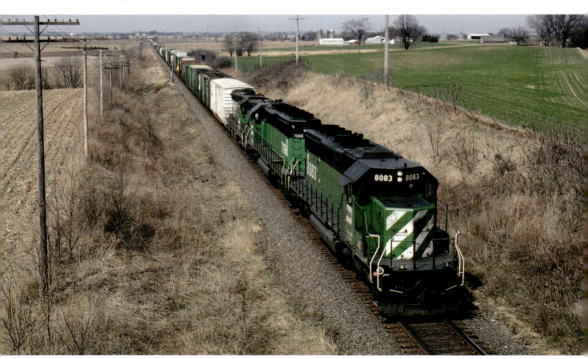

On 9 April 1994, Burlington Northern train 104 heads east out of Milledgeville behind a pair of EMD SD40-2s and a vintage EMD SD9. Some spring crops are already emerging.

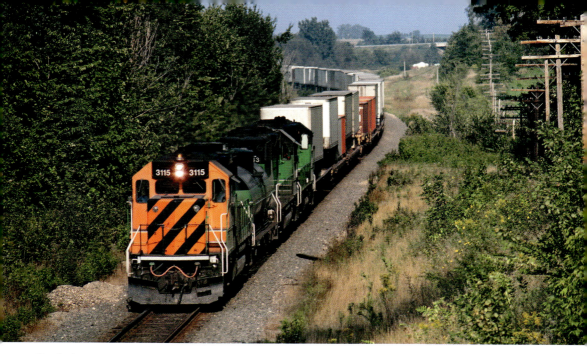

On the late summer day of 5 September 1987, Burlington Northern train 3 speeds through Polo on the C&I (Chicago and Iowa) line. Three 'tiger-stripe' EMD GP50s splicing a fuel tender are power for the hot train heading for Seattle.

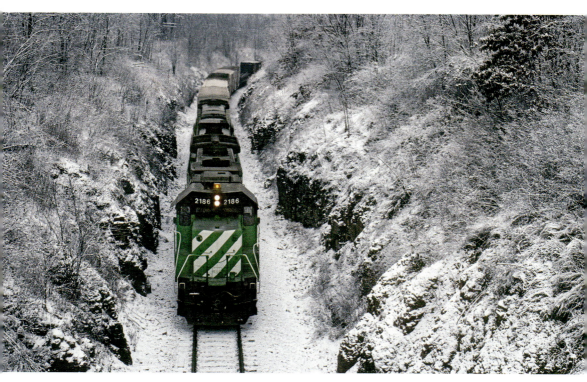

After a light dusting of snow, BN train 204 heads east through a cut west of Oregon on 21 January 1990. On the lead is GP38 No. 2186, a former Penn Central/Conrail unit built in 1970, and trailing are two General Electric B30-7As, part of BN's cabless fleet of locomotives.

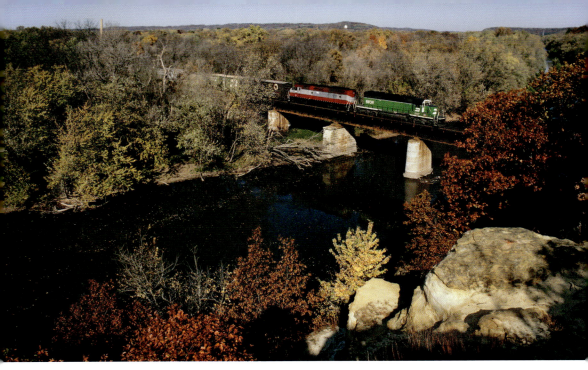

Burlington Northern EMD SD40-2 No. 6836 and Montana Rail Link EMD F45 No. 392 lead BN train 110 over the Rock River at Oregon on the morning of 22 October 1994. MRL No. 392 is still painted in the red and gray of previous owner Wisconsin & Southern.

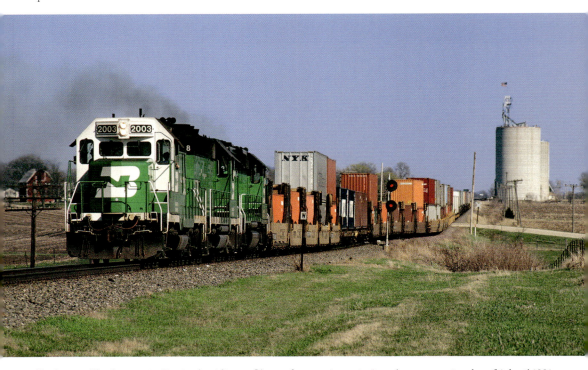

Burlington Northern train 43 exits the siding at Chana after meeting train 2 on the sunny spring day of 6 April 1991. On the point is GP20C No. 2003, a repowered and rebuilt GP20 with a Caterpillar engine. Trailing is sister Cat No. 2008 and an EMD GP39M.

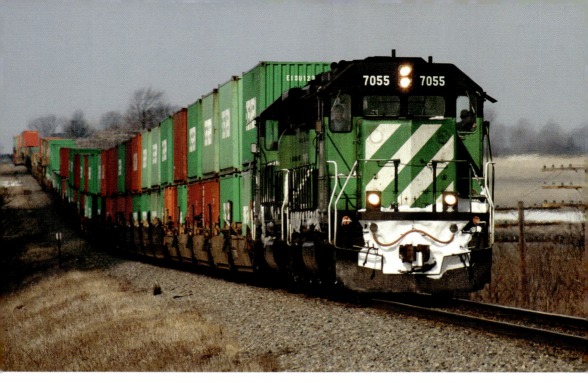

Negotiating the undulating profile of the C&I line in northern Illinois farm county is a pair of Burlington Northern EMD SD40-2s powering eastbound double-stack train 54 west of Flag Center on the morning of 23 February 1997.

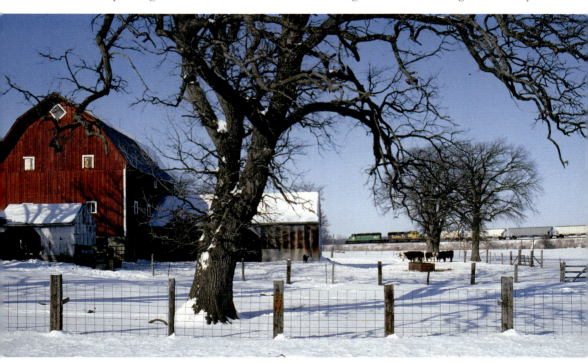

At 2:35 on the afternoon of 13 February 1994, a westbound Burlington Northern freight train passes a farm just west of Flag Center. BN SD40-2 No. 8011 leads a trailing Santa Fe GP50, a sign of things to come with the future BNSF merger ... but we didn't know it at the time.

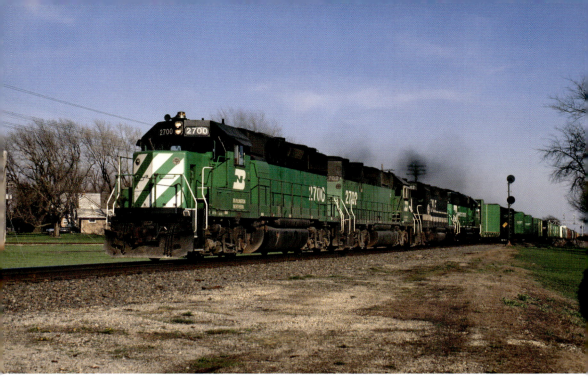

Burlington Northern train 203 rumbles westbound through Flag Center on the sunny afternoon of 16 April 1988. BN No. 2700 is a GP39-2 built by EMD in 1981.

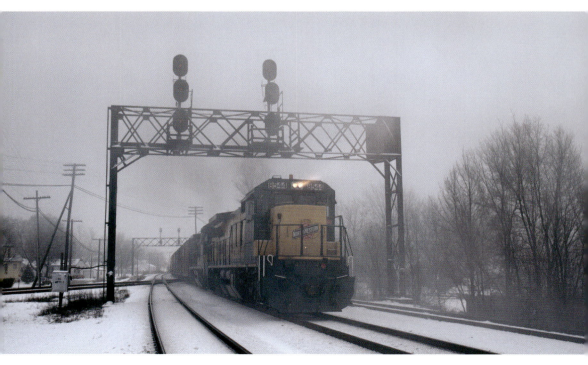

Winter in northern Illinois doesn't always mean lots of snow, but it can bring fog and freezing drizzle. On the first day of winter in 1991, a westbound Chicago & North Western freight bangs over the crossing with the Burlington Northern at Rochelle.

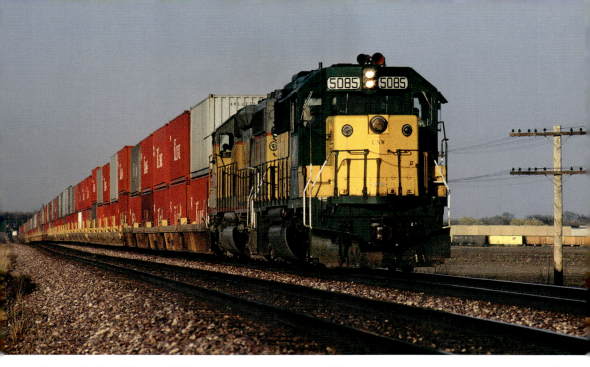

Chicago & North Western GP50 No. 5085 leads a westbound K-Line double-stack intermodal train just west of Rochelle on 16 April 1988. The trackside farm fields here will be the future location of Union Pacific's expansive Rochelle 'Global III' intermodal facility.

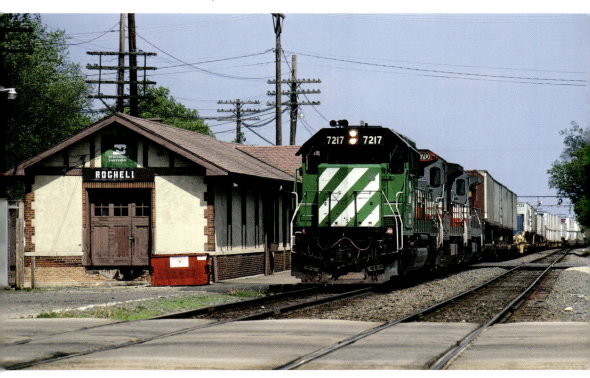

Heading across the country to Seattle, Burlington Northern train 3 passes the old passenger station at Rochelle on the afternoon of 16 May 1992.

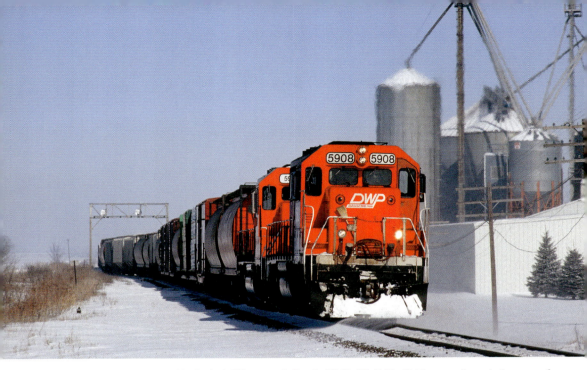

Canadian National train 340, led by Duluth, Winnipeg & Pacific EMD SD40 No. 5908, passes through the town of Steward at 10:21 a.m. on a wintery 13 February 1994. CN operated on the Burlington Northern to Chicago before their merger of Wisconsin Central provided the current routing of this traffic.

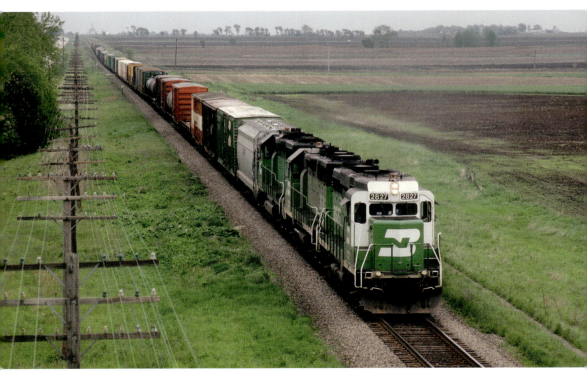

On 20 May 1990, Burlington Northern 2nd 107 cruises west along the pole line at Shabbona on the C&I (Chicago & Iowa) line between Aurora and Savanna.

A Canadian National freight crosses the Chicago & North Western's branch line to Troy Grove between Waterman and Shabbona on 2 April 1995. Powering the westbound train is a pair of unique GE C40-8M cowl locomotives in two different paint schemes.

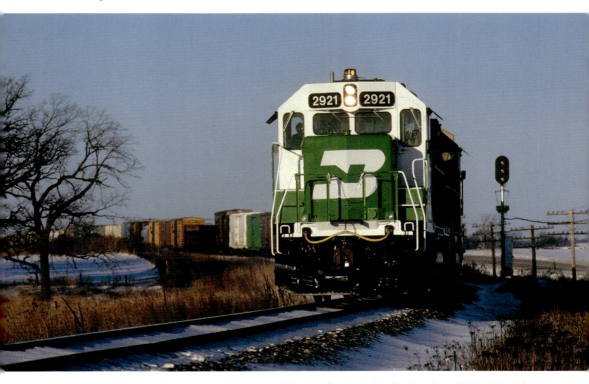

It's a cold winter morning as an eastbound Burlington Northern freight, led by freshly rebuilt EMD GP39E (rebuilt by EMD, hence the 'E' designation), sweeps through the curve approaching Big Rock on 17 February 1990.

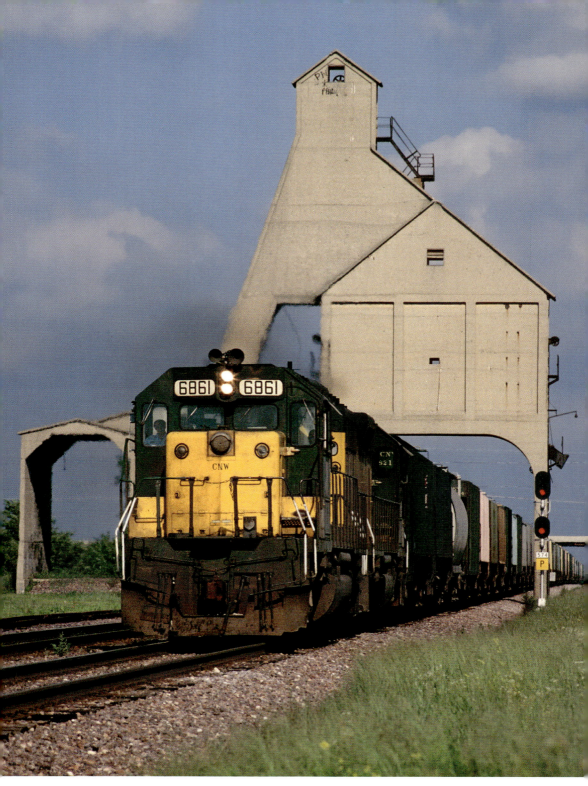
A westbound Chicago & North Western grain train passes under a vestige from the historic days of steam locomotives, a substantial concrete coaling tower, still spanning the main line at De Kalb on 25 July 1993.

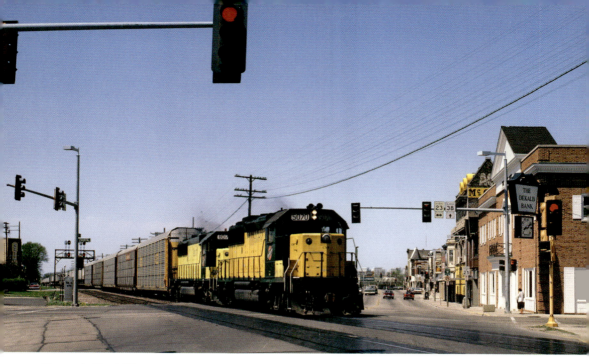

Chicago & North Western EMD GP50 No. 5070, horns blaring, blows by the De Kalb Bank and across the busy intersection of Illinois Highway's 38 and 23 at De Kalb on the morning of 26 April 1987. The traffic lights are red in all four directions!

An eastbound Chicago & North Western coal train pass through farmland west of De Kalb on 9 October 1994. A shiny, new combine stands idle for a moment as a farmer takes a break during harvest time.

Passing through small town Illinois is an eastbound Chicago & North Western trains crossing Third Street at Malta on 25 March 1995.

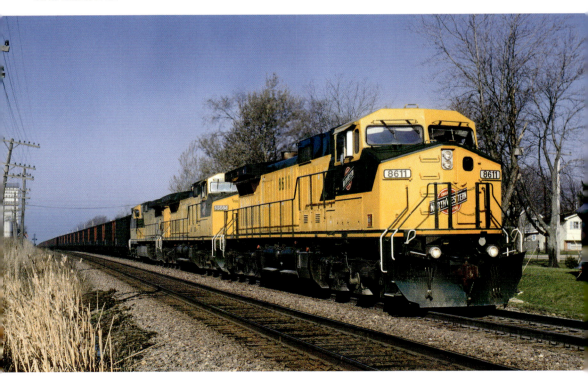

Wearing the final Chicago & North Western paint scheme are three GE C44-9W locomotives hauling an eastbound coal train through Creston on a sunny 2 April 1995.

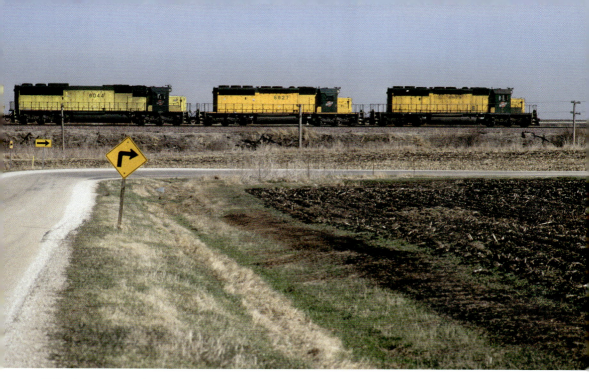

With a hearty turn to the right, Creston Road is going the same place as this eastbound Chicago & North Western freight train. In about 2,000 feet, both will be traversing through the town of Creston on 25 March 1995.

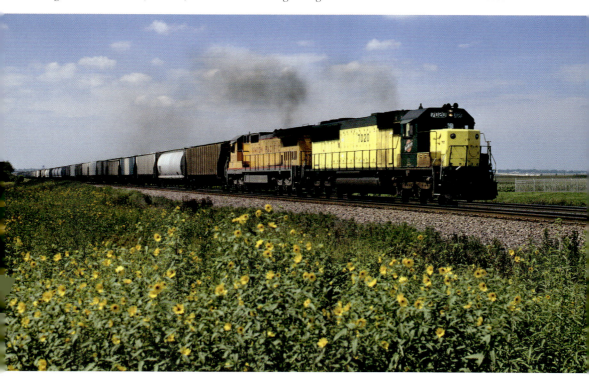

Led by Chicago & North Western EMD SD50 No. 7020 and Union Pacific GE C40-8 No. 9201, an eastbound grain train works past a field of summer flowers between Rochelle and Creston on 25 August 1996.

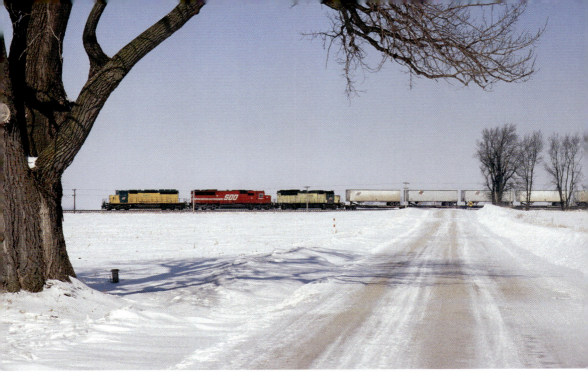

West of Flagg on a wintery 13 February 1994, this westbound Chicago & North Western piggyback train is led by C&NW EMD SD40-2 No. 6901, Soo Line EMD SD60 No. 6053 and C&NW EMD GP50 No. 5078.

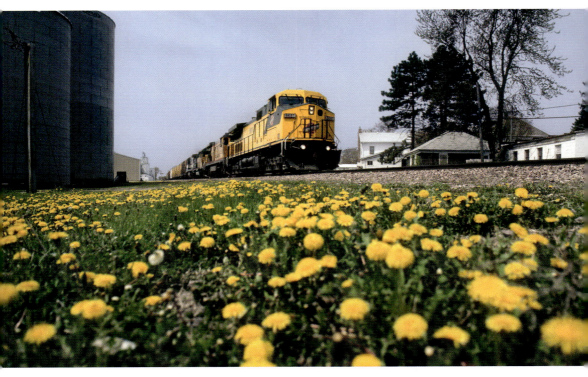

Blasting past bountiful springtime dandelions blooming near the Cartwright Avenue grade crossing, Chicago & North Western GE C44-9W No. 8681 leads an eastbound freight through Ashton on 6 May 1995.

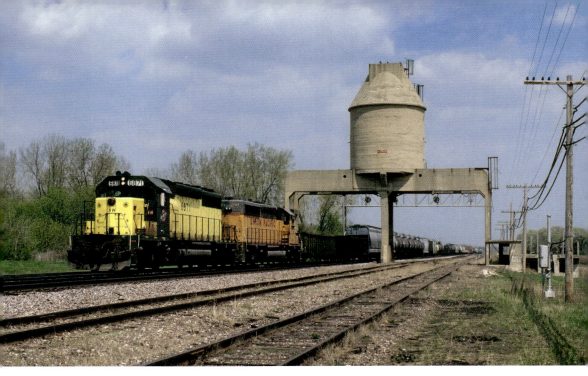

A pair of EMD SD40-2 locomotives, led by Chicago & North Western No. 6871, thunders westbound under the venerable concrete coaling tower that still spans the main line at Nelson on 6 May 1995.

In archetypal small town America, a man mows the lawn and dandelions behind his wood-framed house along the main line tracks of the Chicago & North Western. Crossing gates lower and warning bells ring as an eastbound freight led by Union Pacific and CSX locomotives rushes through Morrison on 6 May 1995.

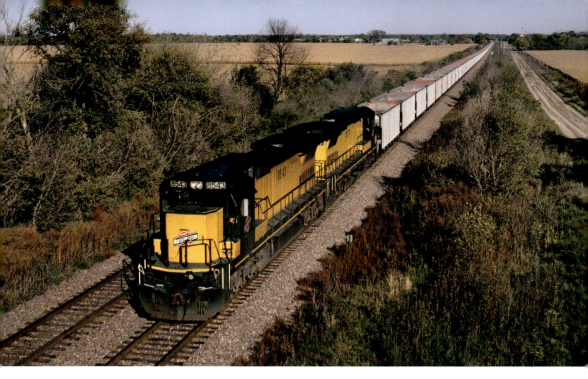

A westbound Chicago & North Western coal empty, heading back to Wyoming for reloading, slices through farm country as it approaches Agnew on 9 October 1994.

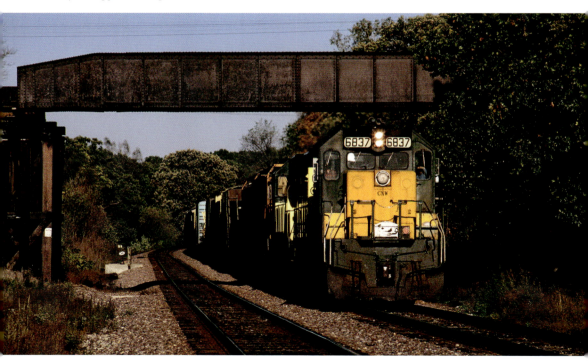

Chicago & North Western EMD SD40-2 No. 6837 leads a westbound freight train under the Burlington Northern's Third Subdivision main line running from Galesburg to Plum River (Savanna) between Union Grove and East Clinton on 9 October 1994.

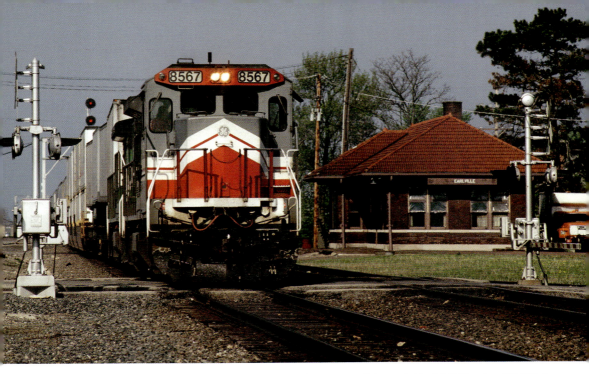

At 8:42 a.m. on 10 May 1992, an eastbound Burlington Northern intermodal train, led by LMX Leasing GE B39-8 No. 8567, passes the old passenger station at Earlville. BN leased 100 of these LMX locomotives built in 1987.

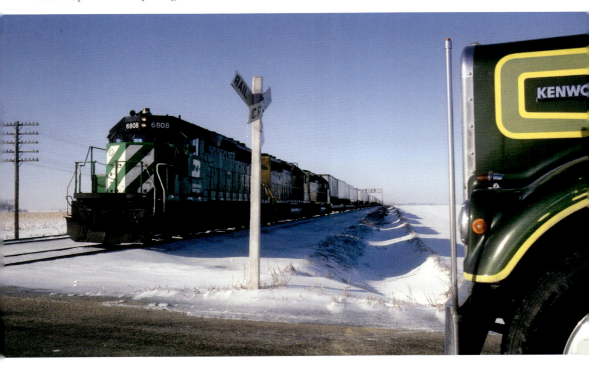

A Kenworth tractor/trailer rig stops at a rural crossing west of Earlville for Burlington Northern train 60 wheeling piggybacked trailers toward Chicago on 17 February 1990. The speedster is led by three EMD SD40-2s, with BN No. 6808 leading two Santa Fe units.

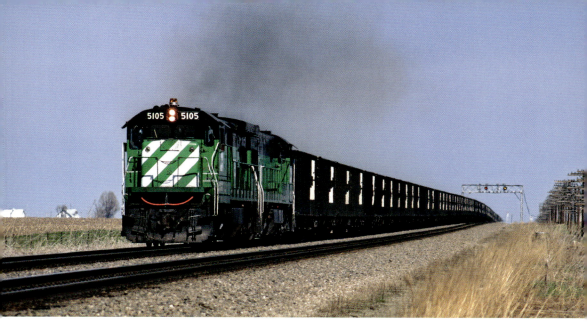

Cresting a rise in the rolling Illinois farmland, a westbound Burlington Northern coal train is west of Earlville on the Chicago to Galesburg main line on 16 April 1988. Powering the train of BN hoppers is a GE C30-7/U30C combo led by No. 5105.

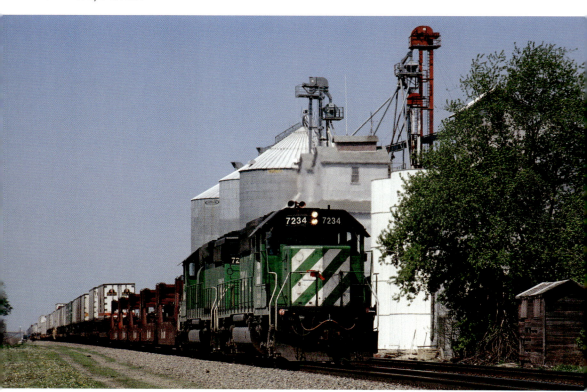

Passing the towering grain elevators at Meridan is an eastbound Burlington Northern intermodal train on 10 May 1992. Apparently, the engineer aboard EMD SD40-2 No. 7234 has tied a red flag to the front railing as extra warning to pedestrians and motorists to clear the way.

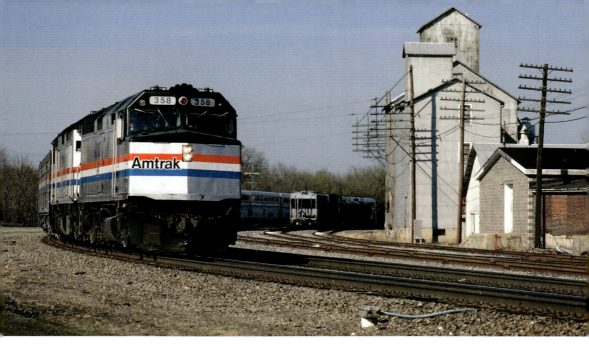

Amtrak's westbound *California Zephyr* curves into Mendota on its trip over the Chicago to Galesburg main line of Burlington Northern on 16 April 1988.

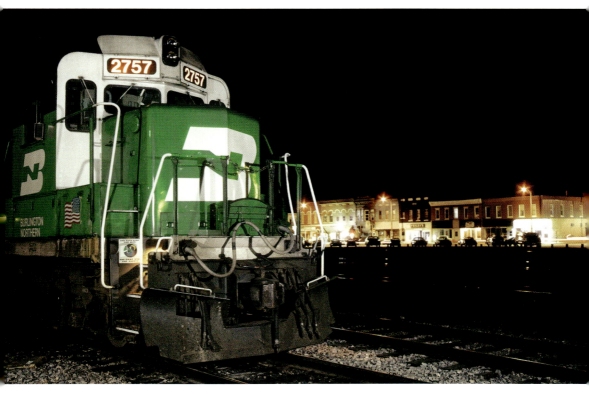

Power for Burlington Northern's Mendota local rests overnight in the small yard at Mendota as the old buildings lining Main Street glow on the evening of 1 May 1992. What looks for the world like an EMD GP30, No. 2757 is actually a GP39E, remanufactured by EMD in late 1991.

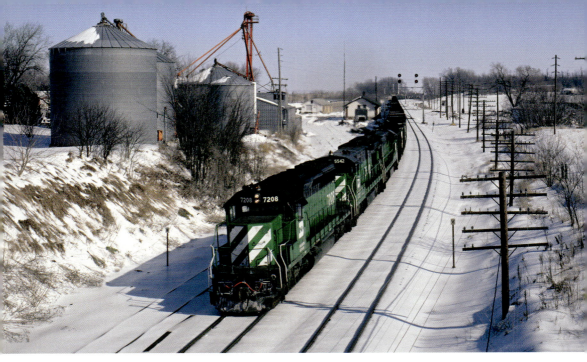

On the quiet and cold winter day of 17 February 1990, a westbound Burlington Northern coal train whisks through the small town of Buda. Powering the empty train is EMD SD40-2 No. 7208 and two GE C30-7s.

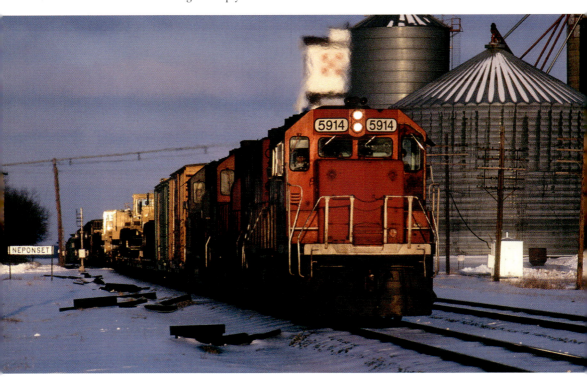

Late winter sunlight illuminates the front of a westbound Burlington Northern freight, powered by a pair of Grand Trunk Western units splicing a DT&I locomotive, rumbling through Neponset and heading for Galesburg Yard on 17 February 1990.

As seen from an eastbound auto pacing on U.S. Highway 34 out of Galesburg, a speedy Southern Pacific intermodal with Chicago on its radar sprints through Oneida on Burlington Northern's Galesburg to Aurora main line on the afternoon of 2 June 1991.

In Burlington Northern's sprawling Galesburg Yard, locomotives and freight cars always seem to be on the move at this important crossroads facility. In front of a wall of stacked shipping containers, BN EMD SW1200 No. 228 switches covered hoppers on 22 June 1996. In the middle of the scene is the one-of-a-kind rebuilt cabless EMD SW10B No. 442.

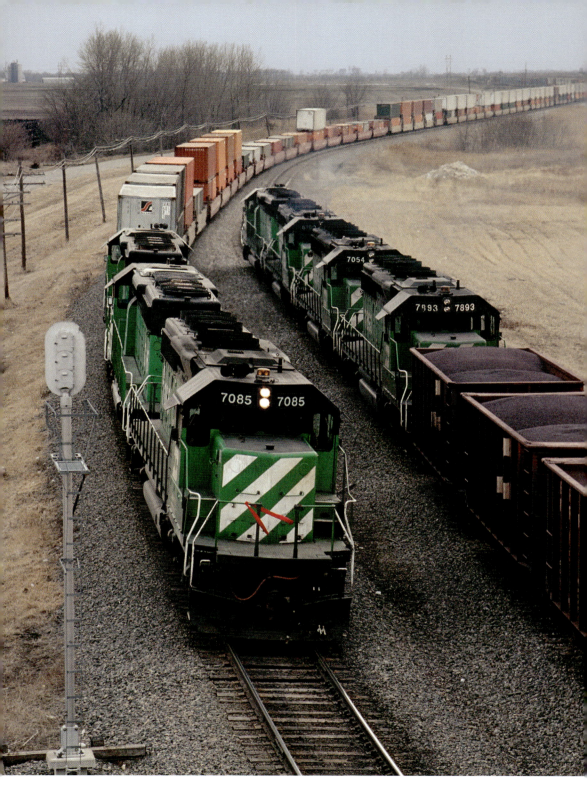
On main line trackage skirting Burlington Northern's Galesburg Yard, a eastbound intermodal train meets a heavy taconite ore train headed for Granite City on 17 February 1991.

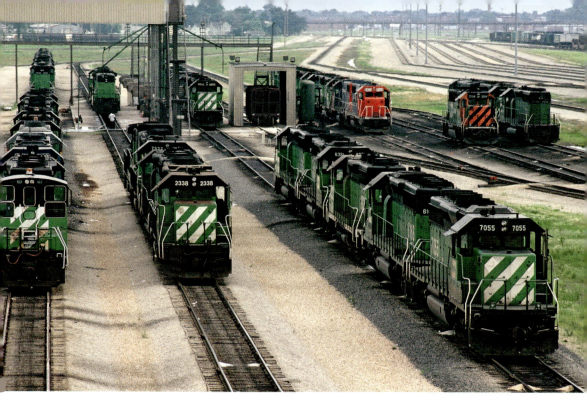

In 1991, Burlington Northern's locomotive facility at Galesburg is mostly a sea of Cascade green EMDs. Only three GE units are visible (two B30-7As and a C30-7) on this second day of June during the annual Galesburg Railroad Days celebration.

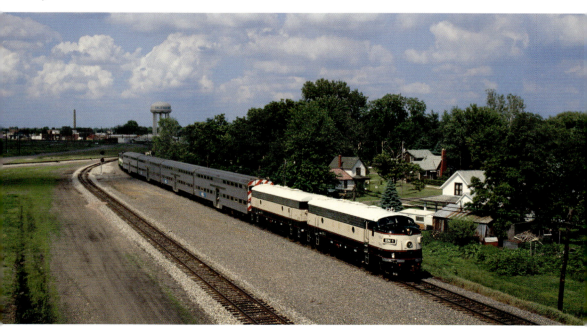

Burlington Northern EMD F9A-2 BN-1 and F9B-2 BN-2 lead a passenger special of borrowed Metra commuter cars and BN E9A No. 9902. The train was giving visitors short rides in the Galesburg area during the city's annual Galesburg Railroad Days event on 2 June 1991.

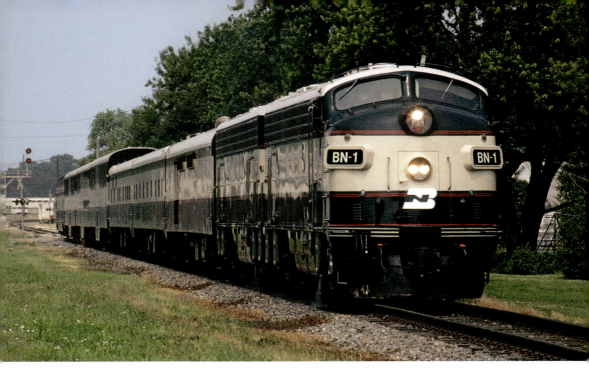

During the city's annual Galesburg Railroad Days, Burlington Northern EMD F9A-2 BN-1 leads a passenger special from Galesburg to Yates City on 24 June 1995. Both BN-1 and F9B-2 BN-2 were rebuilt in 1990, and are painted in Grinstein colors adopted with these locomotives.

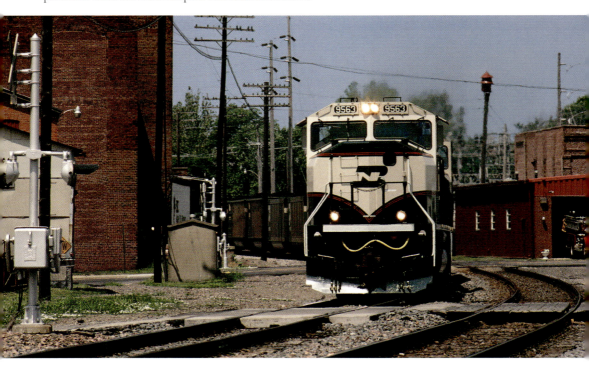

Burlington Northern EMD SD70MAC No. 9563 leads an eastbound coal train over Main Street in Monmouth on 29 June 1997. BN owned a large fleet of these 4,000 hp, A.C. traction locomotives built specifically for unit coal train service.

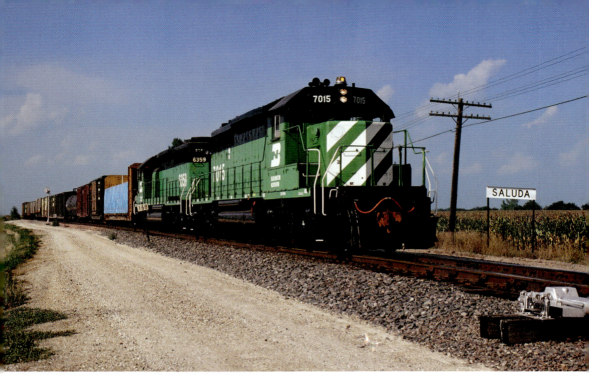

Heading south-westerly on the Burlington Northern Fourth Subdivision main line from Galesburg to West Quincy (and eventually, Kansas City) is a BN freight at Saluda on 27 August 1989.

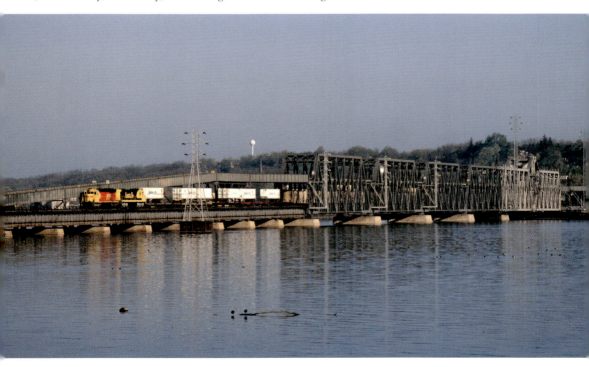

On 24 April 1988, an eastbound Santa Fe freight crosses the Mississippi River from Fort Madison, Iowa, into Illinois on an impressive multi-span deck and truss bridge built in 1927. The top deck is used by a tolled roadway for vehicle and pedestrian traffic on Illinois Highway 9, while the railroad uses the more level lower deck.

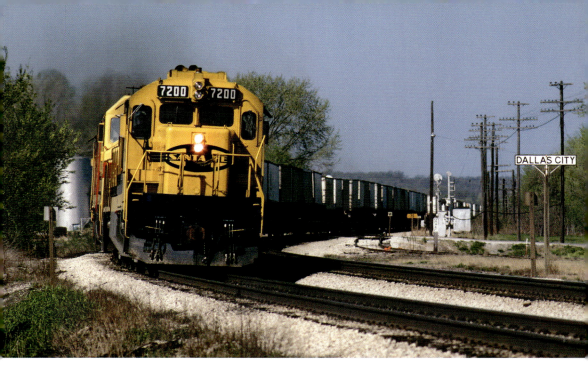

An eastbound Santa Fe piggyback train rolls through a curve at Dallas City on 24 April 1988. Leading locomotive No. 7200 is a remanufactured GE U23B, rebuilt at Santa Fe's Cleburne Shop to a 'SF30B' in 1987, and is the lone prototype of a proposed program to rebuild older U23B locomotives that never materialised.

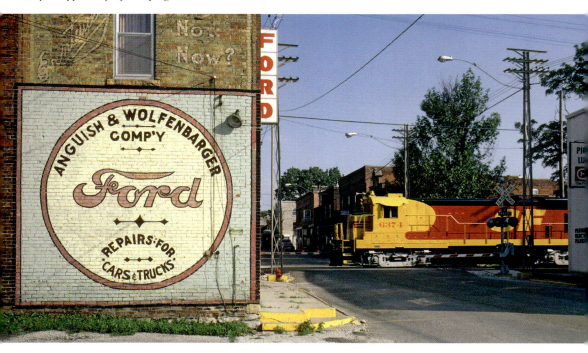

Santa Fe's eastbound 352 train rips though Dallas City, Illinois, on the afternoon of 31 May 1986. The main line crosses Oak Street and divides downtown Dallas City in half, but with the maximum track speed of 70 mph, the trains don't block the street very long! Merger scheme (with Southern Pacific) GE B23-7 No. 6374 leads the Peoria-bound train.

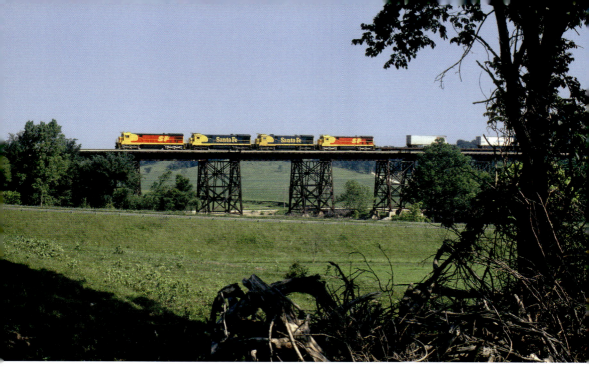

Four GE C30-7s, arranged elephant-style, pull a Santa Fe piggyback train westbound over Media Trestle east of Media on the warm spring day of 31 May 1986. The lead and trailing locomotives are brightly painted for the ill-fated SP-Santa Fe merger, denied by the U. S. Interstate Commerce Commission in July 1986.

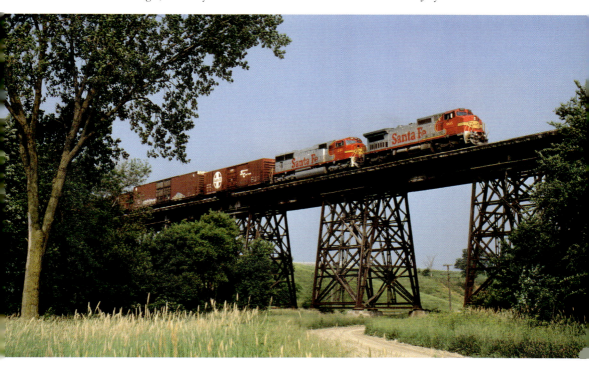

Santa Fe GE C40-8W No. 905 and EMD SD75M No. 240 lead an eastbound freight over Media Trestle just east of Media on 23 June 1996. The BNSF was created by a merger of Burlington Northern and Santa Fe on 22 September 1995, with the railways formally merged into the Burlington Northern Santa Fe Railway on 31 December 1996.

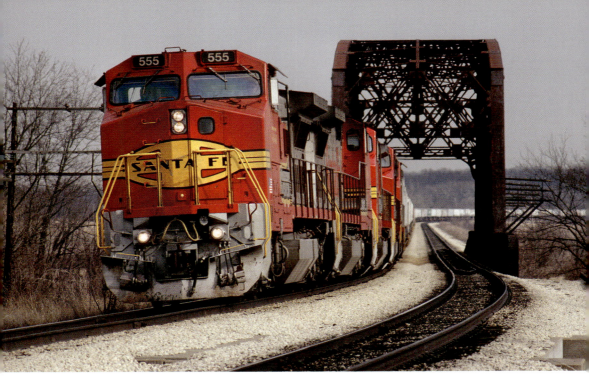

Five Super Fleet GE B40-8Ws power Santa Fe's QNYLA train as it crosses over the Spoon River at Dahinda on 17 February 1991. Beginning in 1989, Santa Fe introduced a modernised version of its famous Warbonnet paint scheme for new North American safety cab units intended as power for high-speed intermodal service trains, and branded these locomotives as the 'Super Fleet'.

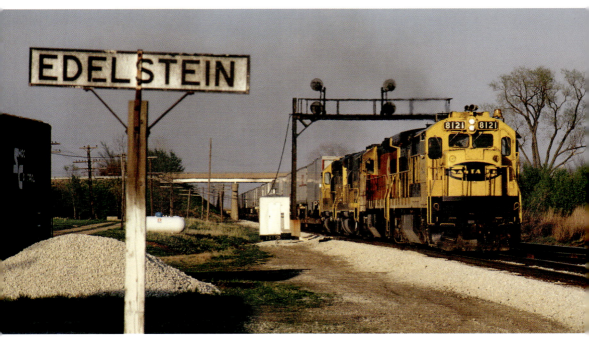

Passing under the Illinois Highway 40 overpass, Santa Fe GE C30-7 No. 8121 leads a westbound piggyback train into Edelstein at the end of the day on 30 April 1988.

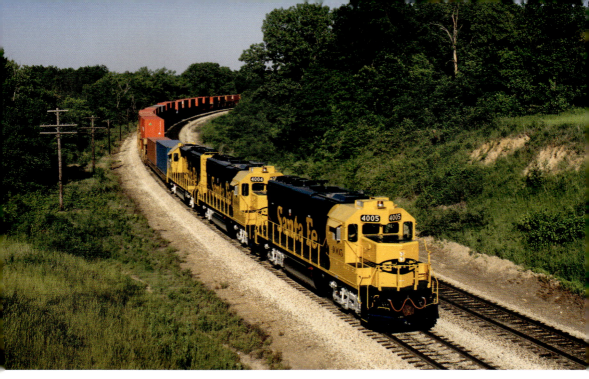

A trio of brand-new Santa Fe EMD GP60s, powering a double-stack intermodal train, fly up Edelstein Hill between Chillicothe and Edelstein on their first run west after completion by Electro-Motive Division. Spotless Nos 4005, 4004 and 4003 shine in the afternoon sun of 4 June 1988.

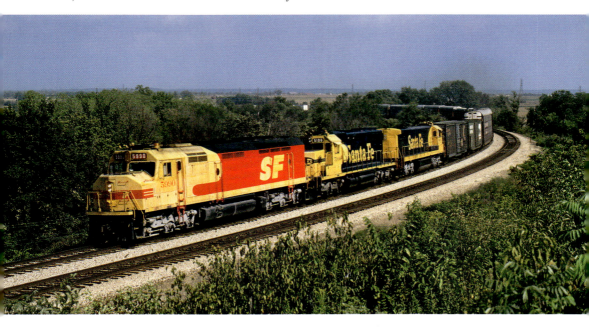

At 3:30 p.m. on the afternoon of 20 August 1988, a westbound Santa Fe freight climbs Edelstein Hill around Houlihan's Curve west of Chillicothe. The lead locomotive is an EMD FP45, built in December 1967 to haul Santa Fe's crack passenger trains. Originally numbered 100, after a rebuilding by Santa Fe in 1982, the locomotive was renumbered to 5990. The big cowl was eventually painted in the 'Kodachrome' colors of the ill-fated SPSF merger in 1986, as seen in this view.

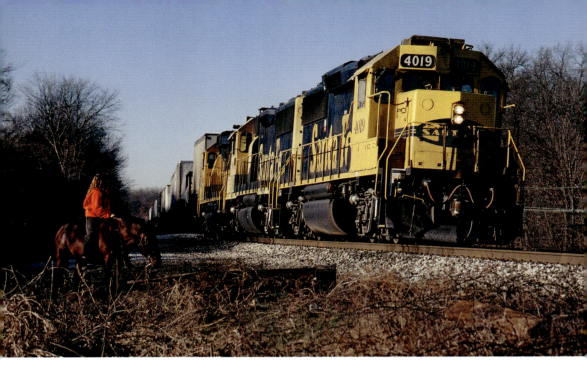

On a snowless 8 December 1990, a girl takes her horse for a ride at the top end of Houlihan's curve, west of Chillicothe on Santa Fe's famed Edelstein Hill. Powering the eastbound intermodal at 2:41 p.m. is a pair of EMD GP60s bracketing a GP50.

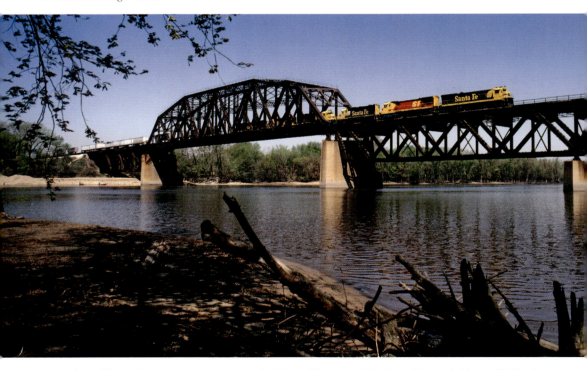

An eastbound Santa Fe intermodal train crosses the Illinois River over this substantial truss bridge at Chillicothe on the morning of 30 April 1988. This double-track bridge, replacing an older single-track bridge in July 1931, is 1,695 feet long.

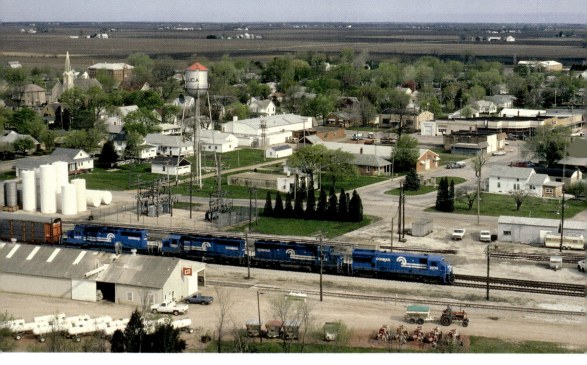

Small town America can be found 110 miles west of Chicago on Santa Fe's main line. In a view from an abandoned coal mine tailing pile that local residents call 'Jumbo', the town of Toluca can cast a spell on the observer. The sweet smell of spring with sprouting trees and fertilized crops; farms and furrowed fields as far as the eye can see; an old water tank telling the world where you are; a farmer riding his tractor down the street after visiting the feed store; the distant sounds of lawn mowers and kids playing outside. And of course, the Santa Fe main line humming with commerce like this eastbound freight with Conrail run-through locomotives, whistling through town, led by rare GE U36B No. 2974.

The fields are plowed and the crops are in on this spring day of 26 April 1997, as a westbound BNSF freight led by a pair of Santa Fe locomotives hustles through Leeds.

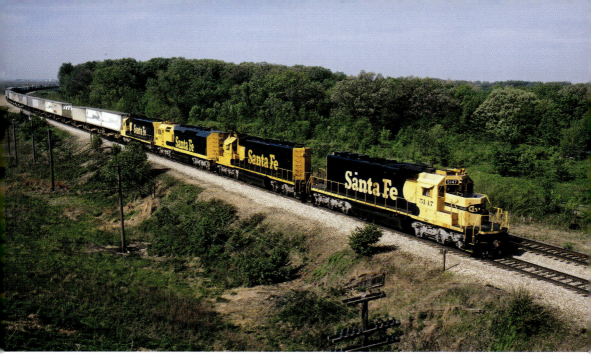

An eastbound Santa Fe intermodal train curves toward Streator at 9:18 a.m. on 10 May 1986. Trailing lead EMD SD40-2 No. 5147 is another SD40-2 (5073), a former Amtrak EMD SDP40F, now rebuilt into SDF40-2 No. 5264 and EMD SD45 No. 5355.

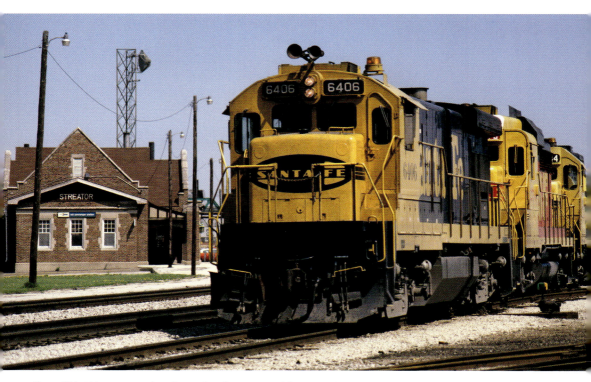

Santa Fe's 102 train switches the yard at Streator, rumbling past the station that once served the railroad's stately passenger trains and now provides the same function for Amtrak's *Southwest Chief* on a sunny 25 April 1987.

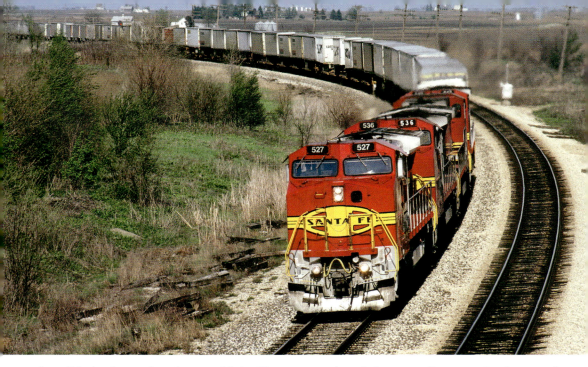

Santa Fe's ultra-hot westbound intermodal, the 199 train, cruises through the curve at Ransom on the afternoon of 2 May 1992. This train carries premium-priced traffic from Chicago to Richmond, California, and a nice set of four Super Fleet warbonnet GE B40-8W locomotives pull the train on this particular day.

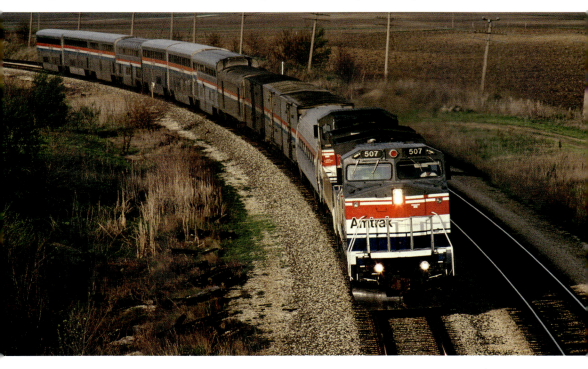

Amtrak's westbound *Southwest Chief*, powered by a pair of GE B32BWH locomotives in 'Pepsi Can' colors, flies through Ransom on 2 May 1992. Deadheading to California is an Amfleet coach behind the power, and today's train has a former Santa Fe lounge substituting for the usual Superliner Sightseer lounge.

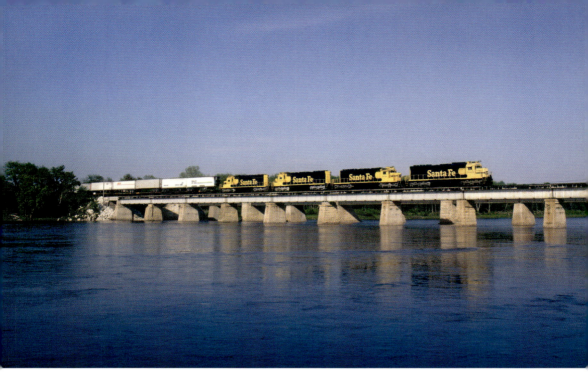

A Santa Fe intermodal train sprints across the Kankakee River Bridge at Lorenzo on the afternoon of 10 May 1986. The westbound train is pulled by a pair of EMD SD45s and a pair of SD40-2s.

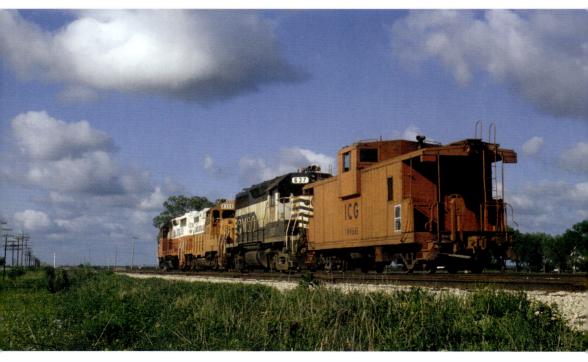

An Illinois Central Gulf 'caboose hop' speeds northbound at Pontiac on the former Alton/Gulf, Mobile & Ohio main line running from Chicago to St Louis in May 1984. A caboose hop is a railroad term used to describe a train consisting of locomotive(s) and caboose only.

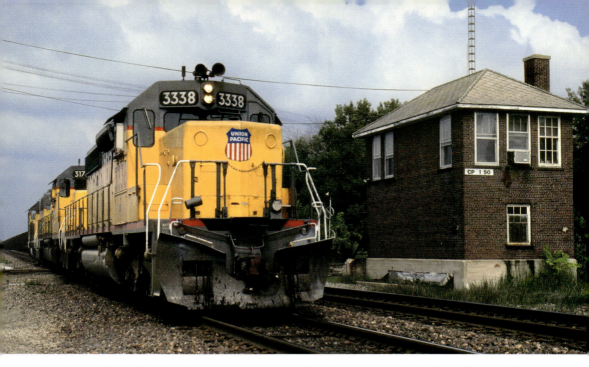

A southbound Union Pacific coal train clatters across the Conrail crossing guarded by Pence Tower at Momence on 8 September 1990. This was formerly the crossing of New York Central (now Conrail) and Chicago & Eastern Illinois/Missouri Pacific (now UP).

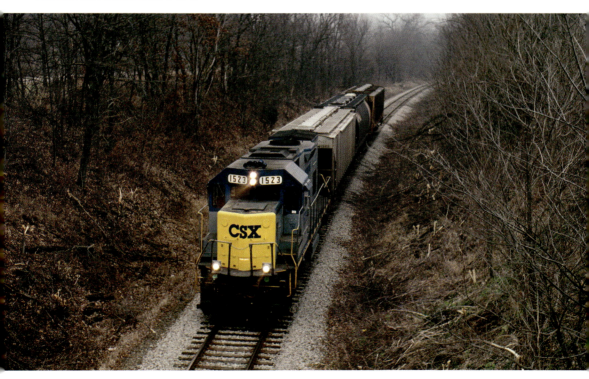

Traveling the old Rock Island line from Bureau Junction to Peoria is a short three-car CSX freight train heading southbound at Putnam on a dreary 23 December 1994.

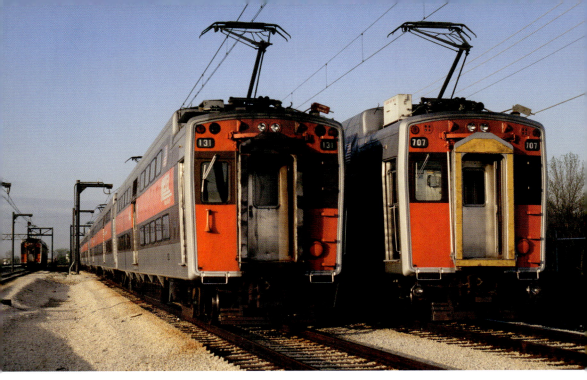

Three Metra Highliner-equipped commuter trains sit at the end of the former Illinois Central electric main line out of Chicago at University Park on the morning of 9 May 1992. The Highliner is a bi-level multiple unit rail car, originally built for IC by St Louis Car Company in 1971, with additional cars later constructed by Bombardier.

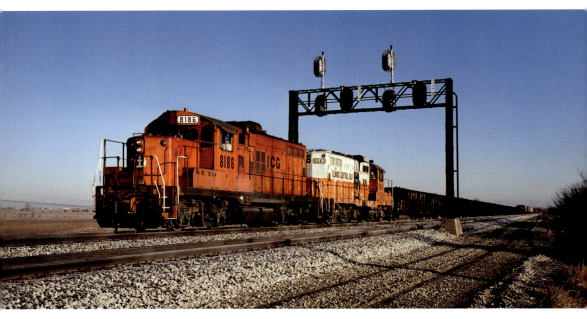

Illinois Central's southbound Markham local passes under a signal bridge at mile 37.8 south of Monee on 21 January 1989. The train is powered by Illinois Central Gulf GP10 Nos 8186 and 8343, rebuilt by the railroad in its Paducah, Kentucky, shops from EMD GP9 locomotives. IC merged with Gulf, Mobile & Ohio in 1972, forming ICG, but after a later reorganisation, ICG dropped the 'Gulf' from its name and became Illinois Central Railroad on 29 February 1988.

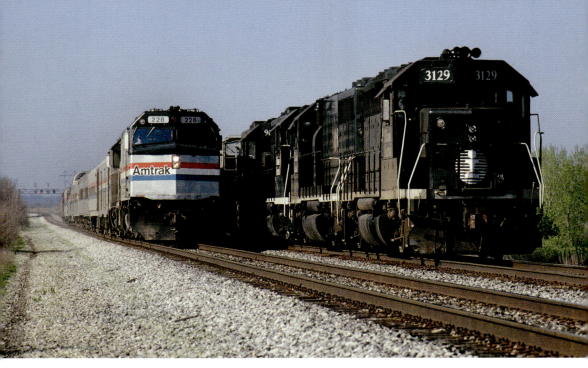

On the morning of 6 May 1990, a northbound Illinois Central freight is held on Track 1 at Manteno to let Amtrak's train 58, the *City of New Orleans*, pass by on its rapid trip north to Chicago.

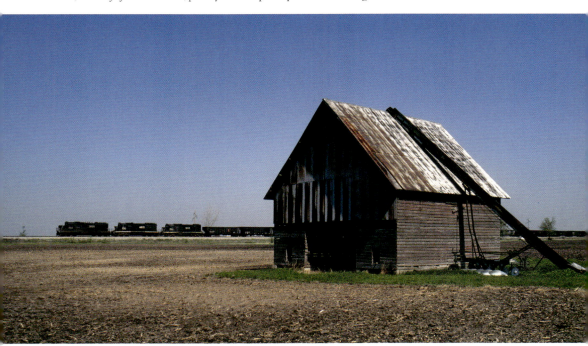

A southbound Illinois Central freight train, with coal hoppers behind the locomotives, passes a picturesque barn between Ashkum and Danforth on 6 May 1990. The modern-day IC locomotive roster was all-EMD; pulling this train is SD20 No. 2035 – a rebuilt SD24 – SD40X No. 6071 and GP38-2 No. 9571, The middle unit, No. 6071, is a rare EMD SD40X built in 1964 and ended up being the first demonstrator of the popular EMD SD40 series.

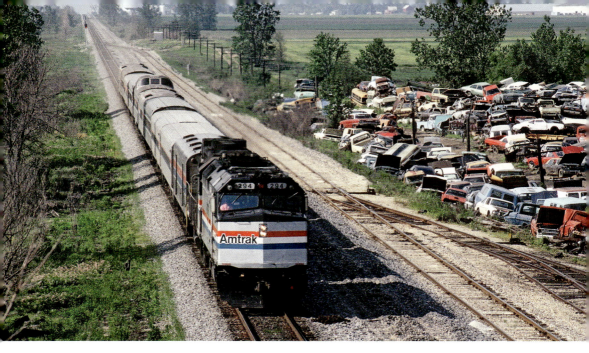

When exploring the Illinois Central in 1989/90, I couldn't get the classic song by Steve Goodman, 'City of New Orleans', out of my mind. During one of the trips I found this junk yard at Otto that I vowed to photograph someday with a certain train. So, on 12 June 1990, here's my Amtrak version of the 'City of New Orleans' as it 'Rolls along past houses, farms and fields, passin' towns that have no names … and the graveyards of rusted automobiles'.

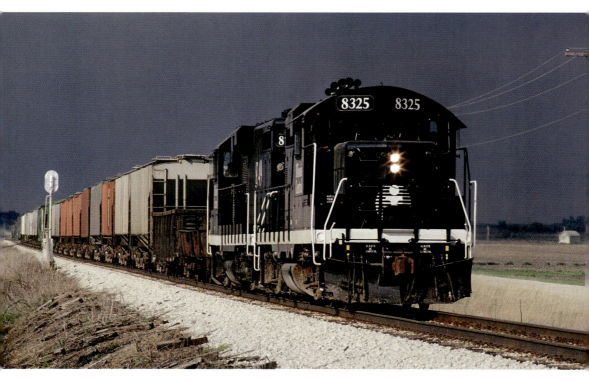

Under a stormy spring sky, an Illinois Central local heads down the St Louis main line out of Gilman south of Melvin on 5 May 1990.

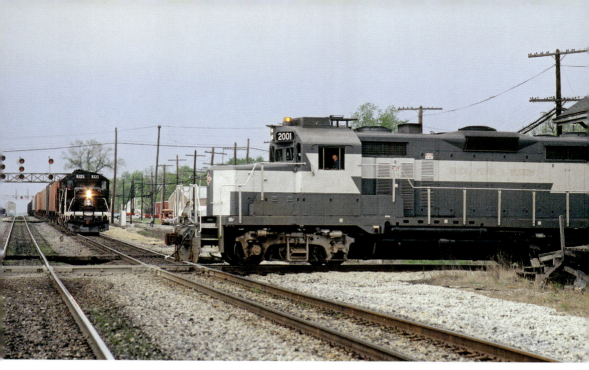

With a southbound Illinois Central freight train waiting, a westbound Toledo, Peoria & Western train crosses the diamonds at Gilman on 5 May 1990. The TP&W in this era was repainting some of its former Santa Fe EMD GP20 locomotives in this New York Central-inspired paint scheme.

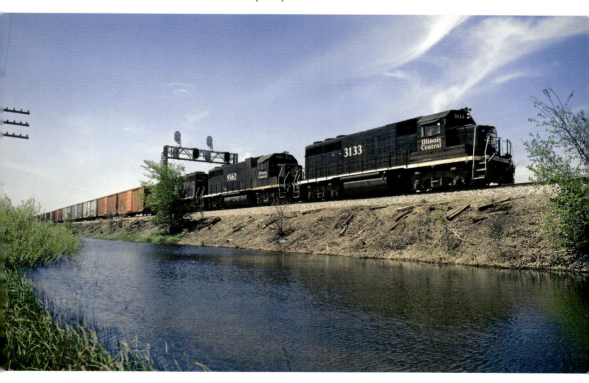

Passing a trackside depression filled with spring rainwater, an Illinois Central freight heads northbound out of Danforth on the pleasant day of 5 May 1990.

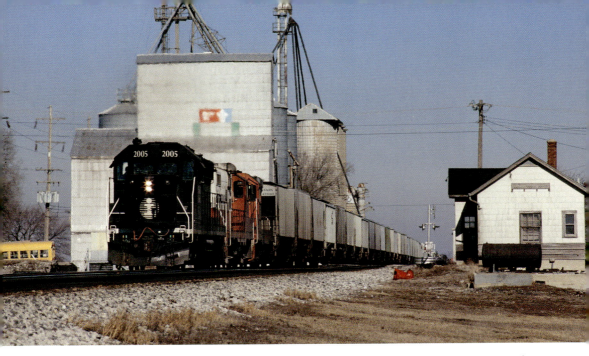

Illinois Central's SCMI freight operating from Chicago to Memphis, Tennessee, passes the old station and grain elevators at Buckley on 21 January 1989.

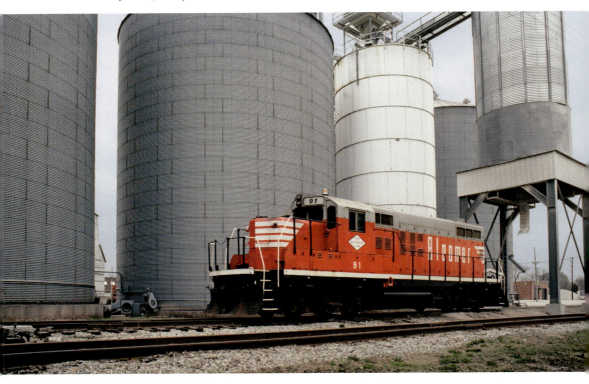

Wearing its Burlington Route-inspired color scheme, Bloomer EMD GP9 No. 91 waits to go to work at Gibson City on 24 April 1993. This short line was formed in 1985, originally operating a former Illinois Central Gulf route between Kankakee and Bloomington, and is primarily a grain hauler called the Bloomer Shippers Connecting Railroad – more commonly known as 'The Bloomer Line'.

A stiff wind from the south moves exhaust smoke from northbound Alco RS11 No. 321 faster than the train itself as a Kankakee, Beaverville & Southern freight crawls along north of Cheneyville on a stormy 24 April 1993.

Powered by Alco RS11 Nos 321 and 318, a northbound Kankakee, Beaverville & Southern freight train departs Cheneyville as it trundles past Illinois farmland on the blustery spring day of 24 April 1993.

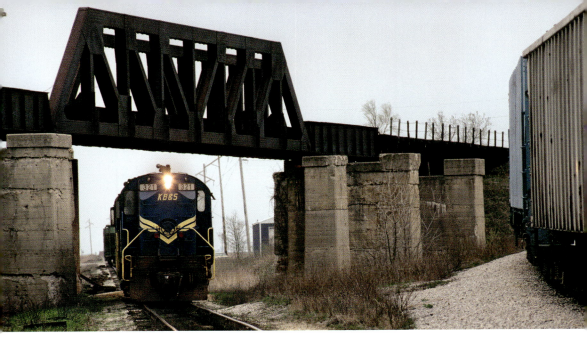

Kankakee, Beaverville & Southern Alco RS11 locomotives switch cars at Iroquois Junction on 24 April 1993. The power is on the old New York Central line to Lafeyette, Indiana, while the bridge overhead is the Milwaukee Road's line to Danville – parts of both line are now operated by KB&S.

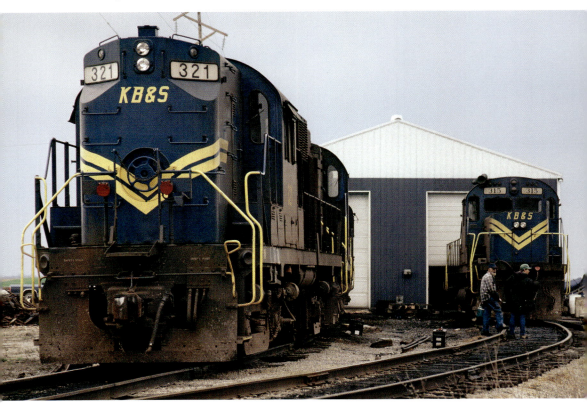

The crew has a last-minute discussion before heading home for the day, as Kankakee, Beaverville & Southern Alco locomotives, RS11 No. 321 and C420 No. 315, sit in front of the railroad's shop at Iroquois Junction on 24 April 1993.

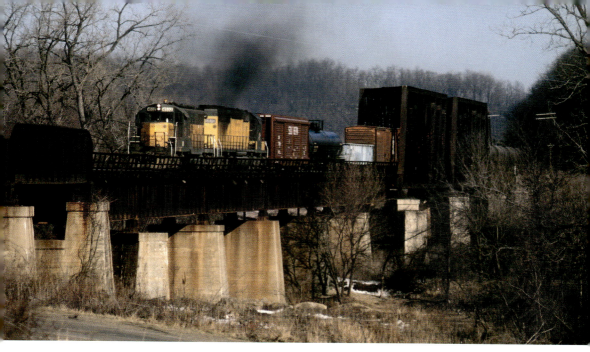

In March 1984, a Chicago & North Western freight train crosses over the Burlington Northern, Kickapoo Creek and Kickapoo Creek Road on this massive bridge near Peoria while heading south on the railroad's 'SI' (Southern Illinois) line running from Nelson to St Louis.

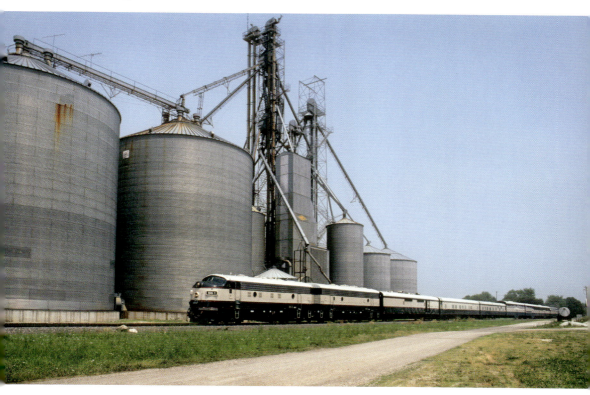

Burlington Northern's EMD F9A-2 BN-1 and F9B-2 BN-2 roll out of Yates City on 24 June 1995. The passenger train is operating on the Galesburg to Peoria route as part of Galesburg Railroad Days.

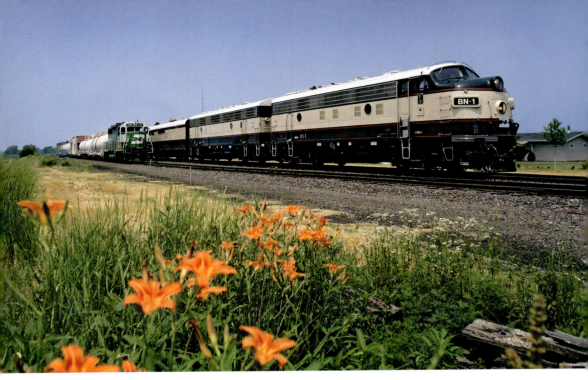

Burlington Northern's executive passenger train passes a weed sprayer work train at Yates City on 24 June 1995, giving participants of the annual Galesburg Railroad Days a ride on the railroad's Peoria line.

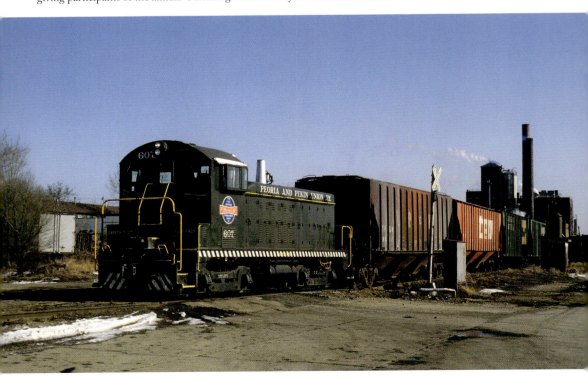

Peoria & Pekin Union Railway EMD NW2u No. 607 switches industrial trackage along the Illinois River at Peoria in March 1984.

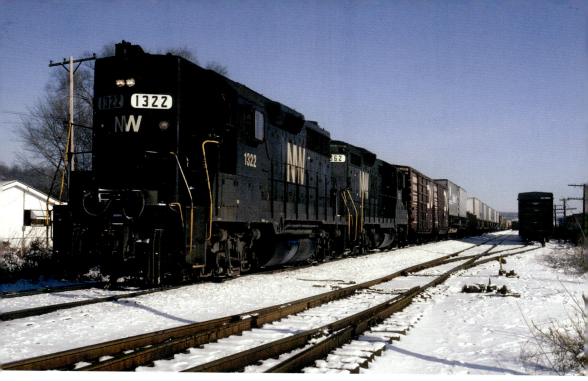

A westbound Norfolk & Western freight rolls through East Peoria in December 1983. The train is powered by EMD GP35 No. 1322 and EMD GP9 No. 662, both equipped with N&W's standard high-short hoods.

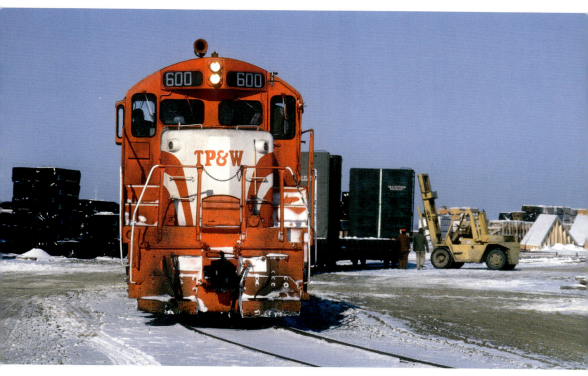

Toledo, Peoria & Western's Morton Switcher, powered by the road's lone EMD GP18 No. 600, switches a lumber yard at Morton on 16 December 1983.

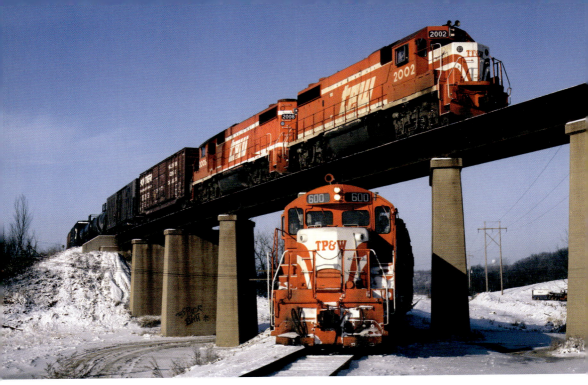

On 16 December 1983, two Toledo, Peoria & Western trains pose at the Farmdale trestle near East Peoria. Above is train 24, the the Effner Local, with GP38-2 Nos 2002 and 2008, passing over the Morton Switcher powered by GP18 No. 600.

A Chicago & Illinois Midland freight curves through downtown Pekin on 17 February 1991. Mostly a coal-hauling road, C&IM operates from Peoria through Springfield, to Taylorville, which includes a rail-to-barge transfer service at Havana on the Illinois River.

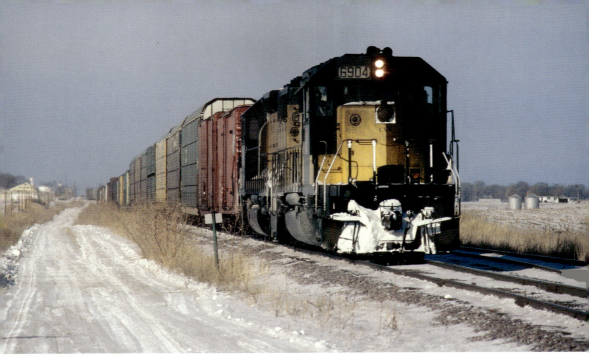

Bound for St Louis, a southbound Chicago & North Western freight train departs the crew change point and yard at South Pekin on the cold winter day of 26 January 1985.

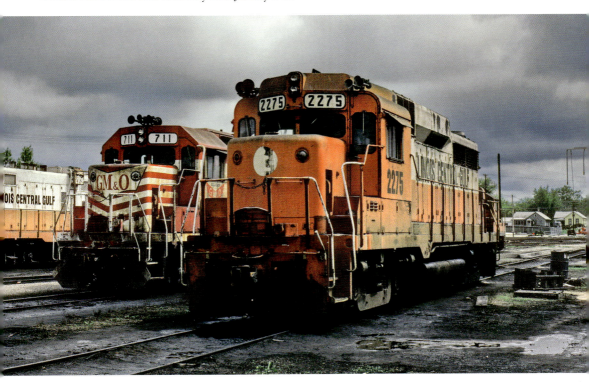

Illinois Central Gulf EMD GP30 No. 2275 rests at ICG's Bloomington yard engine facility in May 1984. The locomotive is a former Gulf, Mobile & Ohio unit that is equipped with Alco trucks from a trade in, while one track over, EMD GP38 No. 711 still carries its original GM&O colors.

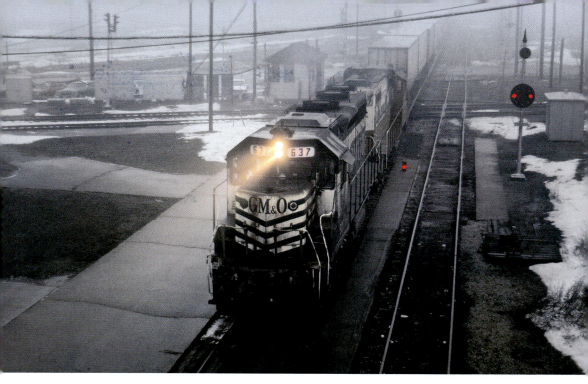

Emerging from a cold winter fog in Bloomington is a southbound Illinois Central Gulf 'slingshot' piggyback train led by Gulf, Mobile & Ohio EMD GP35 No. 637. The train is rattling over the diamonds past BN Target tower, a ground level shack that protects ICG's former GM&O Chicago to St Louis main line with N&W/NS' Peoria line and Conrail's Pekin branch.

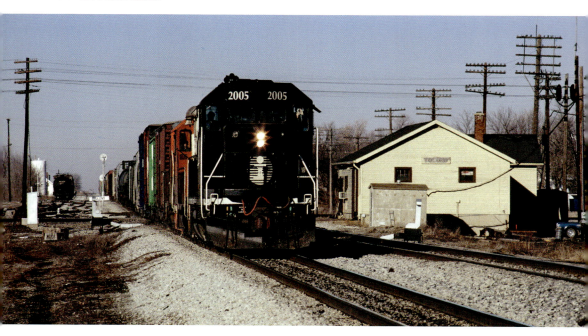

On 21 January 1989, Illinois Central's SCMI freight, operating from Chicago to Memphis, Tennessee, passes through the interlocking at Tolono, where the IC main line crosses the Norfolk & Western (Norfolk Southern) main line between Danville and Decatur.

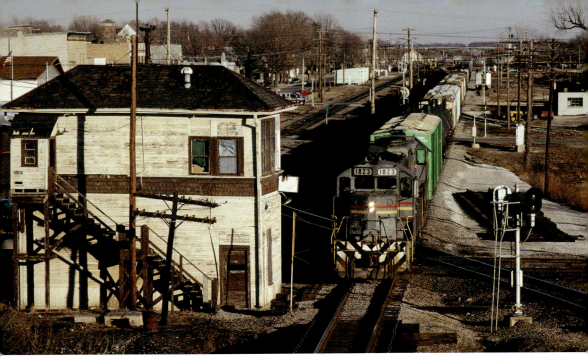

CSXT EMD GP16 No. 1823, still in the gray Family Lines System paint scheme, brings a westbound freight past the tower guarding the crossings of the Illinois Central's main line and Union Pacific's former Missouri Pacific main line (angled route in photo) at Tuscola on the afternoon of 21 January 1989.

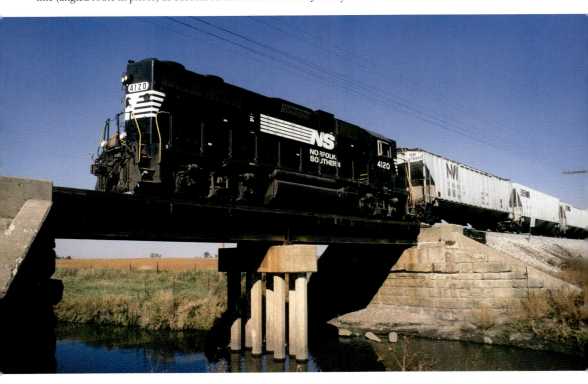

A westbound Norfolk Southern local, powered by EMD GP38AC No. 4120, crosses a bridge over the Embarras River between Philo and Tolono on 11 October 1995.

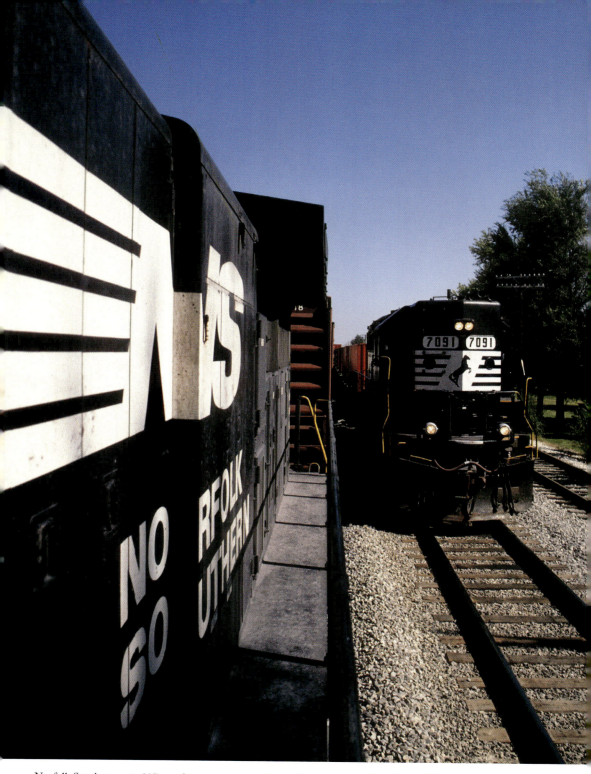

Norfolk Southern train 207 speeds past a westbound long distance local in the siding at Tolono on 11 October 1995. The westbound intermodal is led by EMD GP50 No. 7091, while the local freight is powered by lone GE C39-8 No. 8631.

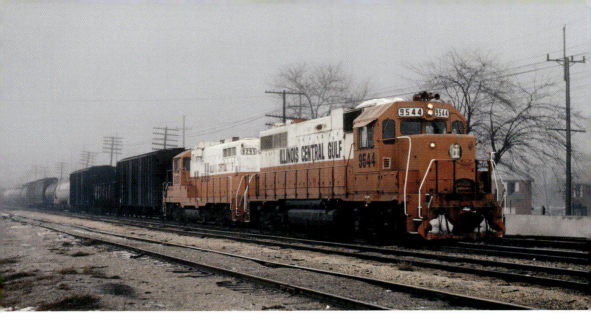

An Illinois Central Gulf freight train passes through Decatur on a very gloomy day in March 1984. Both locomotives are painted in ICG's orange and white paint scheme carried over from predecessor Illinois Central after the merger with Gulf, Mobile and Ohio in 1972.

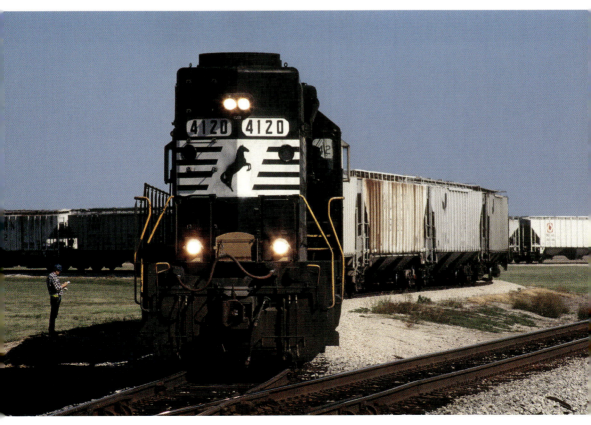

Norfolk Southern EMD GP38AC No. 4120 switches the large Frito-lay grain plant east of Sidney on the afternoon of 11 October 1995.

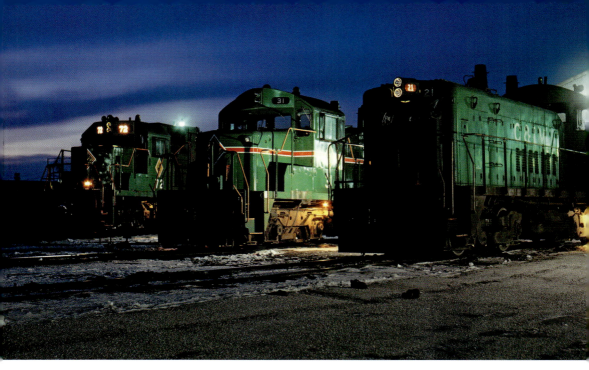

A lineup of Chicago & Illinois Midland power rests at the railroad's shops at Springfield on the evening of 26 January 1985. All-EMD, left to right is a SD38-2, a RS1325 and a SW1200. C&IM owned the only two EMD RS1325 locomotives ever built – Nos 30 and 31.

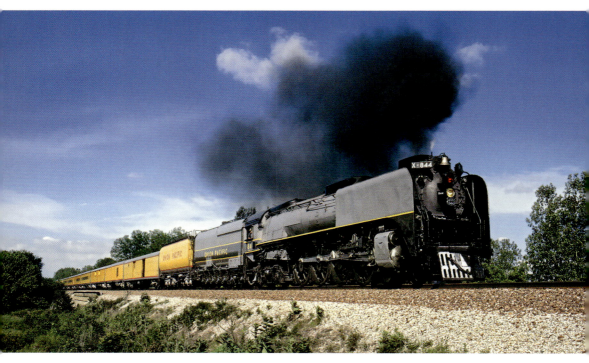

Union Pacific 4-8-4 No. 844, decked out in two-tone 'Greyhound' paint, crosses the West Fork of Shoal Creek west of Hillsboro on 14 June 1990. The Northern steam locomotive pulled a round trip excursion from St Louis to Findlay Junction on UP's Pana Subdivision during a National Railroad Historical Society Convention.

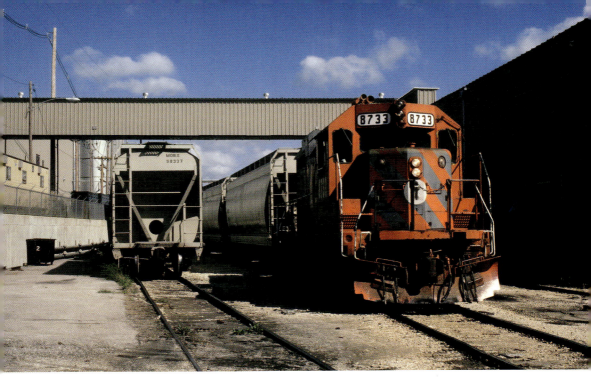

Illinois Central Gulf EMD GP11 No. 8733 switches a sizable plastics manufacturing plant on the south-east side of Jacksonville in September 1984.

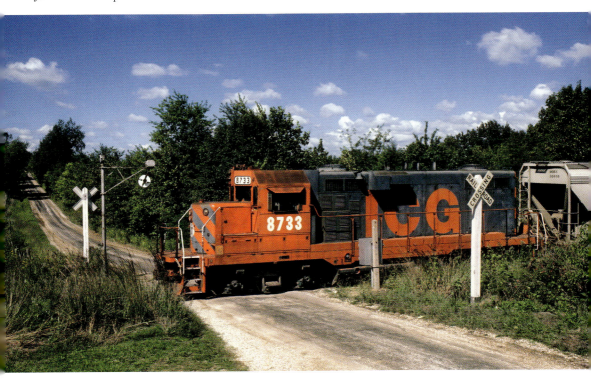

An Illinois Central Gulf local freight crosses over Lake Jacksonville Road grade crossing, protected by a vintage steam-era wigwag signal, as it approaches Woodson on the trip south to Roodhouse in September 1984.

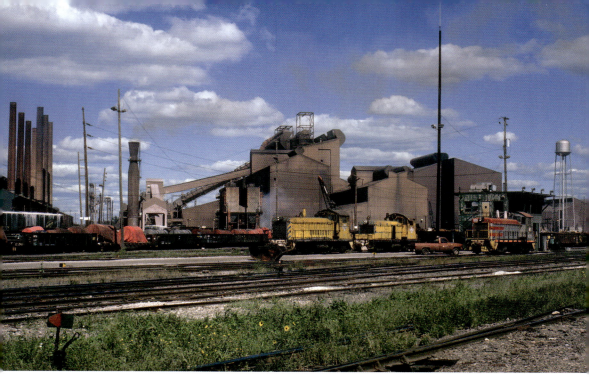

Near East St Louis, the yard parallel along 14th Street in Granite City at the south end of the sprawling Granite City Division of National Steel hosts a trio of EMD plant switchers, including SW1 No. 600 built in 1951.

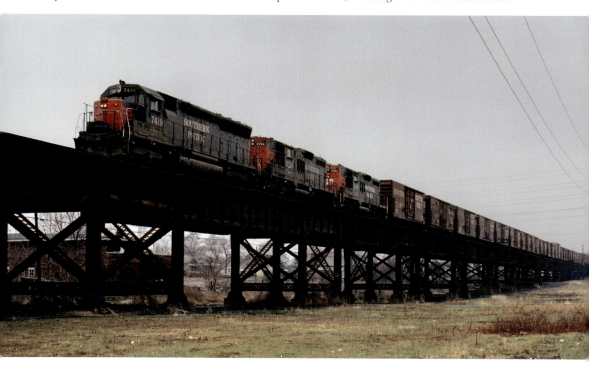

A westbound Southern Pacific freight train treads the long, elevated viaduct approach for MacArthur Bridge over the Mississippi River at East St Louis in December 1984. Pulling the train is EMD SD45 No. 7419, followed by EMD GP9 Nos 3734 and 3361.

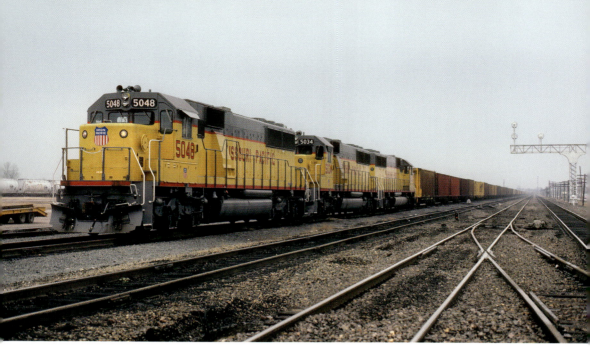

Three brand-new Missouri Pacific EMD SD50 locomotives power a coal train at Dupo in December 1984. Dupo is located south of St Louis on the Illinois side of the Mississippi River and is the location of MP's major yard in the area.

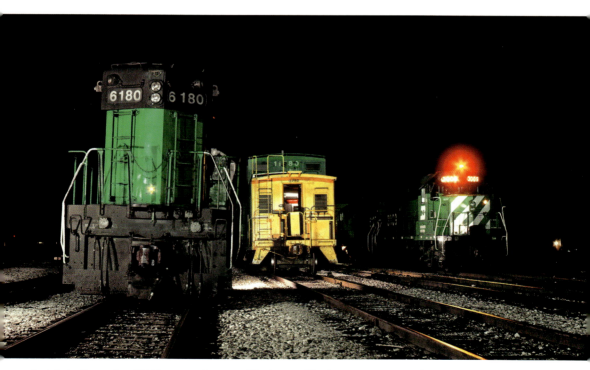

A night in September 1984 features a line-up of Burlington Northern equipment at Centralia. On the left is the local switcher, EMD SD9 No. 6180, along with the local's caboose. On the right, a freight prepares to head south, led by former Chicago, Burlington & Quincy EMD GP40 No. 3009 and another SD9, No. 6127.

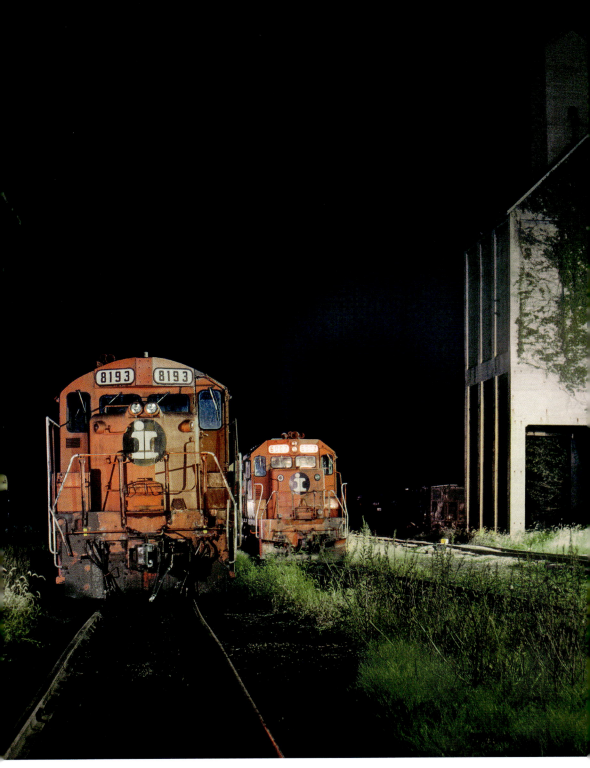

At Centralia, under the imposing coaling tower left over from the days of steam locomotion, Illinois Central locomotives idle the evening away on a September 1984 night. Paducah-rebuilt EMD GP10 No. 8193 stands one track over from EMD SD40 No. 6002, exhaust eddying up into the black sky.

A southbound Union Pacific intermodal train, powered by Conrail locomotives, sprints past the old grain elevators at Ina on 25 April 1993. This is a former Chicago & Eastern Illinois, later Missouri Pacific, main line.

In the pouring rain, an Indiana Hi-Rail freight slowly rumbles over the ancient Wabash River Bridge just east of Grayville on 25 April 1993. IHRC soon filed for bankruptcy in 1994, with the corporation gone by the end of 1997 and this line abandoned soon thereafter. On top of that, this bridge collapsed during a flood on the night of 12 January 2005, sending two spans into the water that were eventually removed by Army Corps of Engineers and sold for scrap.

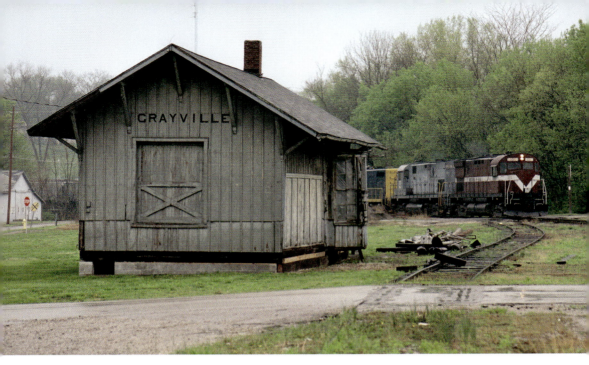

An Indiana Hi-Rail freight ambles into Grayville on 25 April 1993. The train is powered by an eclectic trio of locomotives, led by a former SP&S/Burlington Northern Alco C425 No. 325 painted in company colors. Trailing is a former Louisville & Nashville Alco C420 No. 315 and former Santa Fe EMD GP7 No. 342.

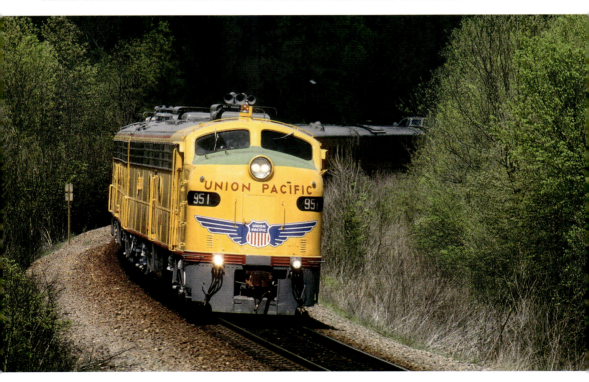

Fresh from a rebuild at Paducah, Kentucky, Union Pacific's A-B-A set of EMD E9 locomotives lead a special passenger train around a curve into Grimsby on 26 April 1993.

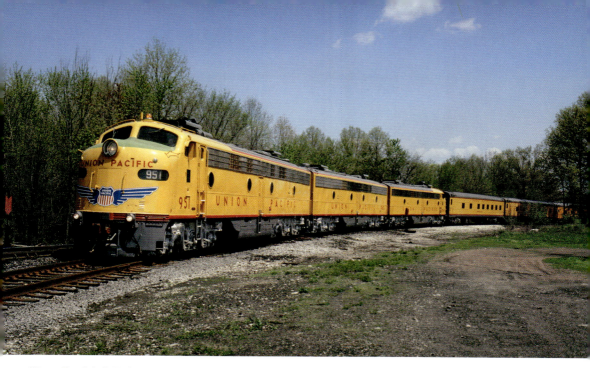

Union Pacific's A-B-A set of E9s are fresh from a rebuild at VMV in Paducah, Kentucky, and are now headed west at Benton Junction on 26 April 1993. The train departed Paducah in the morning and headed up the Illinois Central main line to Akin Junction, where it began its trek west toward Benton and home rails.

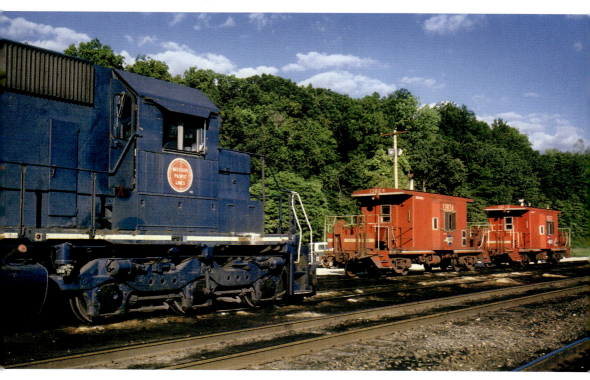

Missouri Pacific EMD SD40-2 No. 3097 sits at the engine facility of the small yard in Chester in September 1984, with two of the railroad's unique cabooses keeping it company.

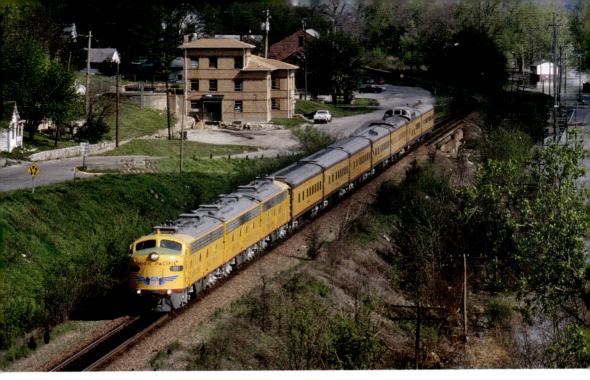

After a rebuild, Union Pacific's trio of classy EMD E9 locomotives pull a passenger special through Chester during their maiden run on 26 April 1993.

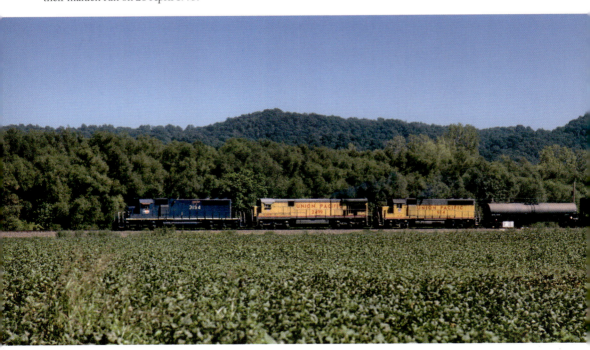

A Union Pacific freight, led by Missouri Pacific EMD SD40-2 No. 3194, rolls northbound through Howardton in September 1984. UP bought MP and Western Pacific, combining these railroads into its system on 22 December 1982. By 1994, all MP motive power was repainted and, because of some outstanding bonds, the Missouri Pacific name finally officially disappeared when it was fully merged into the UP on 1 January 1997.

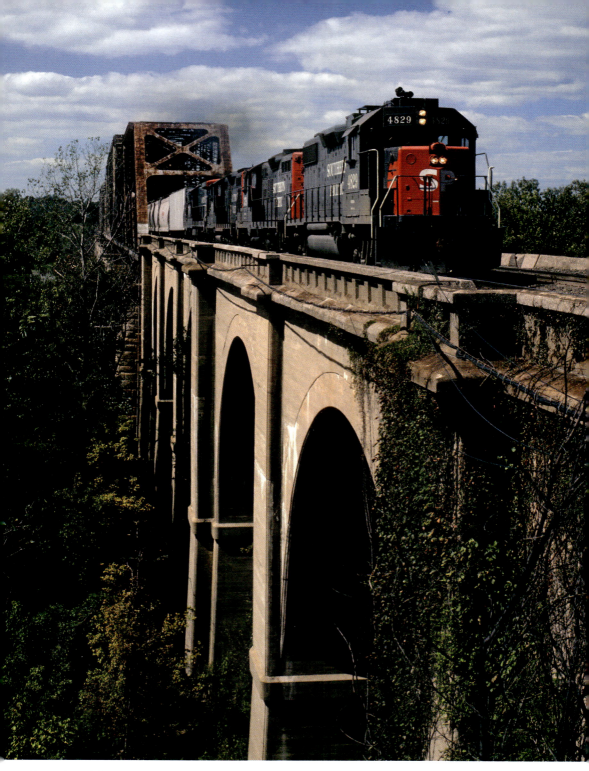

An eastbound Southern Pacific (ostensibly, subsidiary St Louis Southwestern, commonly known as Cotton Belt) freight train crosses the massive Thebes Bridge over the Mississippi River jointly owned with Missouri Pacific in September 1984.

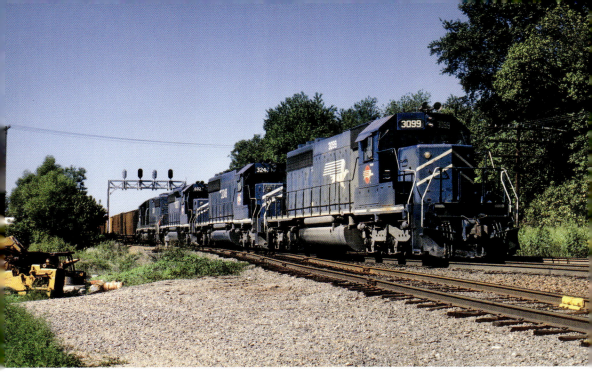

With a lead locomotive emblazoning a 'Screamin' Eagle' logo on the side, a quartet of Missouri Pacific SD40-2s cruise through Wolf Lake with a coal train on the Chester Subdivision in September 1984.

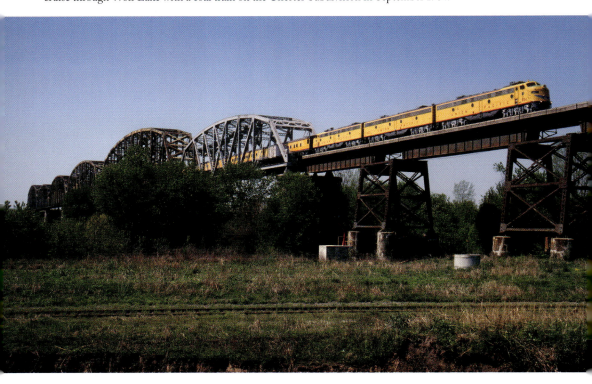

Entering Illinois from Kentucky, a Union Pacific passenger train led by three freshly rebuilt E9 cab units crosses the enormous Illinois Central bridge over the Ohio River at Metropolis on 26 April 1993.